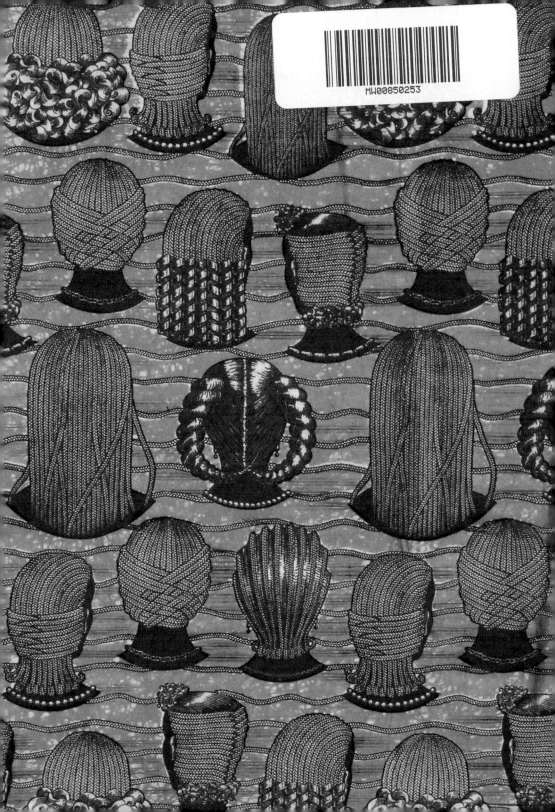

AFRICA
IS IN
STYLE

BÉRÉNICE GEOFFROY-SCHNEITER

ASSOULINE

To all the African designers, famous and still anonymous, whom I had the pleasure of meeting. And all my apologies to those whom I was unable to mention in these limited pages.

b

ack-combed buns, slim-waists, hoop skirts. The girls arrived proudly clutching small handbags, ready to twist with their lovers. The Bamako clubs in the 1950s were packed, the air was electric. There was drinking, laughing, dancing, flirting. And there was a lot of showing off. They were beautiful, young, and rich. They wore the latest styles from the West—this was a generation filled with joy and freedom. Through Malick Sibidé's tender lens, a whole new Africa showed what it had to offer. It was playful, modern, and extremely magnetic. The Zazous in Bamako, Mali, one more elegant and witty than the next, were an ephemeral, fragile microcosm, dancing from one party to the next, expressing their individuality to the tunes of swing and bebop, before the dawn of the chaotic days of decolonization.

And then there are the wiser, more classical, glorious iconic photographs by the great Seydou Keita, Sibidé's fellow citizen. The images are of Africans standing alone or with their families. They are cropped at the bust or appear full-length, standing in front of curtains, proudly holding trophies like radios, or showing off their proudest possessions, such as bicycles or even Peugeot 203s. They are still, obedient, and aware that their images are being captured for eternity. A young father is draped in his ample bubu (an oversized occasion dress), presenting his children with great pride; a stately odalisque nonchalantly rests her elbow on a checkerboard blanket; a dandy with thick black glasses ostensibly smells a rose; turbaned and flirtatious girls stand astride a scooter. They all know they play a role in Bamako society, and they're here to show it. This is what the staging, with all its props—chic clothes, scarves, jewels, watches, sewing machines, pens even—is all about. In the wizardry of the studio, richly colored fabrics—dots, swirls, stitching—serve as theatrical backdrops, in front of which being and seeming become one.

another country, another Africa. This one's cockier, more sophisticated, rowdier, hipper, expressed through the portraits of Jean Depara from Zaire. In the beginning of the 1950s, Kinshasa was a joyful capital, cosmopolitan and colorful, where the hot rhythms of the rumba and cha-cha could be heard day and night. The photographer was drawn to Franco, the star singer of the moment, and spent his days at the Kwist, the OK Bar, or the Sarma Congo, the city's famed clubs. At night, with his flash across his shoulder ("like an bow and

arrow," he would say), he toured all the fashionable spots (the Afro-Mogenbo, the Champs-Élysées, the Djambo-Djambu, the Oui, the Fifi, the Show Boat). He would photograph the mysterious night revelers, who excitedly bought his prints. The rich black-and-white images capture a carefree but nostalgic spirit, somewhere between trendy and retro. It is Dolce Vita set to jazz at the moment of the last call.

The hip, the well-dressed, the *sapeurs* as they were known, were all about ambiance and elegance. Their golden rule was to wear the latest from Paris and Italy, but make it African. Their movement was strictly coded, its do's and don'ts making it all the way to Europe, to the Matonge neighborhood in Bruxelles, to Châteaurouge in Paris. The *sapeur* was an object of desire covered in brand names, and he could go into town, into one of the many Brazzaville clubs, and show off his status by showing off his trophies, his clothes and duly labeled accessories. It was a "label dance," of sorts.

these sublime images tell only part of the story, of course, the part about the burgeoning urban middle class still stunned by its economic and social success. Contributing to the development of fashion as a language in its own right, African studio photography nevertheless masked the reality of another Africa; daily Africa, an Africa that's alive, spontaneous and proud of its patterns and richly colored bubus, an Africa that ingeniously combines the modern and the traditional, an Africa supported and fed by many influences. It's an Africa that is European, American, Caribbean, and nationalist, but it's also an Africa that knows how to constantly reinvent what it wears and

how it wears it. Take, for example, how African manufacturers appropriated the wax process for fabrics, which developed in Holland more than one hundred and fifty years ago. The extravagant graphics and shimmering colors that can be had leave almost no trace of their foreign origins. Evidence of cross-culture can also be found in the markets in Abidjan, Dakar, and Bamako, where elegant women can be spotted wearing the portrait of a head-of-state or the bulky silhouette of a household item or even cell phone on their chest (or sometimes even on their backsides!), as absolute symbols of success and modernity.

To define his own style, with his own fabrics: this was Malian designer Chris Seydou's mission as early as the 1960s. Then the Nigerian designer Alphadi took up where he left off. But beyond what these two fathers of African fashion were able to dream up, there remains a fashion reality that's still prosaic, clashing in colors, filled with artificial dyes and imported cotton. Using traditional African patterns and fabrics such as mud-cloth for Western cuts like jackets and miniskirts, their creations, their clothes challenge all the rich ancestral customs that lie behind the two joyful, rhythmic syllables *bubu*.

embroidered bubu, woven bubu, white bubu, richly colored bubu, bubu for men, bubu for women, bubu for special occasions, bubu for everyday life. The range can make us Westerners pale in jealousy, condemned as we are to wear suffocating uniforms ever since the Industrial Revolution. For in Africa, getting dressed is still about the art of seduction. It's about the ability a king or ruler has to fascinate his people, the way a dandy or spouse quiets a partner; it's the power to turn heads.

The bubu is to Africa what the sari is to India. Much more than clothing, it is finery. On top of being a costume, it's a mark of ethnicity. It's what designers in our part of the world usually call a philosophy or a style. The term bubu—the word is a French spin-off of the Wolof word *mbubb*—very quickly came to designate all clothing or tops put on over the head. It was originally distinguished from another rather vague term, the *pagne* which simply refers to fabric knotted around the waist.

but more than just differing in form, these two clothing practices also divide Africa in two. One is strongly influenced by Islam and its lifestyles (in sum, the eighteen countries between the Atlantic and Lake Chad); the other is less responsive to Allah's word and its roomy clothing (the region between central Africa and South Africa, including certain areas in East Africa). For the bubu comes from the Sahel grasslands and the savanna, brought to sub-Saharan Africa by its great trade populations—mostly Muslim—including the Soninke people, the Manding people, the Toucouleur and the Haussa peoples. What a coincidence it is that the descendents of these brave nomads are the ones to wear the most shimmering bubus and the showiest tunics. Nevertheless, for a long time, the populations in tropical areas rejected the loose garment, the sleeves of which would fill with wind. Was the resistance cultural or simply practical? The adoption of such an easy, generic term as *bubu* is not only a reflection of the growing French colonial presence in West Africa, but also of the complex network of ethnicities and their dress codes.

In reality, however, there's a wide range of use and styles, each with its own name in the various African languages and dialects. It's harrowing work for ethnologists to sort through some twenty-two expressions designating the bubus and shirts of the Mende ethnic group in Liberia alone. It's dizzying for historians to distinguish between 137 names for the clothing of the Haussa people of Nigeria and their 256 different embroidered motifs!

aside from these somewhat fanciful categories, there remains a strong form and a simple design that calls for decoration. In terms of beauty and appearance, embroidery is king. In addition to being a decorative grammar, it becomes a talisman, a love potion, a magic formula, a seduction. It wriggles around the neck, radiates out from a pocket, and sometimes even conquers the bottom of the tunic, both in front and back. Could there be a better way to present oneself, especially when bowing on the ground to the Almighty? There is nothing random about the waves and curls, the hooks and lines. The Haussa's bubus include a protective circle, while other tunics in Nigeria have a propitiatory spiral. Liberian bubus present a magic square. The art of embroidery is in fact what is taught by the masters of the Koran, who are experts in calligraphy. Embroiderers, who are greatly respected and are all men, belong to educated, well-read circles. The wisest and most skilled among them are given the privilege of embroidering the caps, the head being the most important part of the body for Muslims. For it is what rises toward the sky and to God.

The truth is, today, fabrics imported from Europe or Asia —sometimes they're made in China—have gradually replaced

traditional embroidery and indigo dying. Fabric studios in Dakar, Abidjan, and Bamako roar with the sound of electric sewing machines. Signs read *Ambiance-Couture, Venus Couture, Couture-Top-Miss,* their visual and poetic quality competing with signs for beauty parlors. And yet, big stylists are bringing back the bubu and the *pagne* waist cloth. Take, for example, the very pop designs of the Ghanaian Teteh Adzez, who champions the traditional; or the luxurious modernized bubus made in muslin by Pathé Ouédraogo, known as Pathé. Winner of the prestigious *Ciseaux d'Émeraude* award in 1998, he today heads a forty-person company and is developing his superb Sahelian lines of embroidered leather across sub-Saharan Africa. His work challenges the reigning concept of African fashion as being either folkloric or exotic.

although couture is incredibly alive, dynamic, even inventive in Africa, it is nonetheless in danger. An economic and cultural gap separates the small, anonymous tailor in Dakar or Bamako from the big and greatly admired designers working on the other side of the Mediterranean, like Alphadi or Xuly Bët. And yet there are many budding designers, young self-taught artists who nurse the hope of being able to show their talent one day and present their first collection. Sometimes the dream becomes a reality.

This was the case for Cheikha Bamba Loum from Senegal, who was widely recognized at the Dinard International Fashion Awards. Even more than a consecration, it was a nudge in the right direction for the 20-year-old designer. His first prêt-a-porter line *Sigil*—meaning simply "hold your head up"—is a

good reflection of his spirit. In Africa, "doing fashion" means hard work. For Cheikha, as for many others, it means playing a sociological, artistic—even an economic—role. Representing new values, Cheikha's fashion is urban, young, interracial. It's also an alternative to prêt-a-porter from abroad. Local embroiderers add sophisticated designs to the raw denim material he uses to make elegant hooded jackets or baggy North African–style pants.

This same energy can be found in the work of the Cameroonian Juliette Ombang, the dynamic designer of the Black Giraffe line. Already obsessed with fashion at age 11, this graduate of the Esmod school in Paris constantly experiments with traditional African materials such as raffia, wool, cotton, *bogolan, ndop,* and hides, giving them new life and transforming their traditional use. Founder and host of the Yaounde Fashion week, Ombang now dreams of establishing a real fashion school in Cameroon. "In this field, there are real problems with regard to training and skill," she explains. "Most designers in Africa don't have the basics. They do everything unusually. But, fashion is math." Ombang adds with conviction, "Africa has to represent itself now, and it must consume its own products. Thanks to fashion, we can hire workers and reduce poverty."

t his wish was fulfilled by a great woman in African fashion, the Senegalese Oumou Sy. A clothing and costume designer, this self-taught artist has cultivated a heritage of African textiles by founding a design school in Dakar, the Centre de Formation aux Arts et Techniques Traditionnelles et Modernes du Costume et de la Parure, also known as Leydi.

Drawing inspiration from Fulani and Manjack techniques, and using wickerwork, raffia, and fine fabrics, her designs are bold and modern, and extraordinary enough to take your breath away. Her Calebasse, Baobab, Fromager, and Palmier dresses, all accentuate her genius. Oumou Sy's work is a subtle combination of tradition and experimentation. This does not stop her from sometimes mocking over-consumption, designing models she names Femme-Parfum (Perfume Woman), or, even more symbolic, the magnificent, futuristic Femme-Cyber (Cyber Woman).

C laire Kane also seeks to strike a balance between the modern and traditional. Senegalese at heart, she opened her own fashion company in Dakar. As early as 1990, she was already silk-screening woven *pagne* waist cloths. Eleven years later, the designer launched her famous reggae collection, stamped with eye-catching red, yellow, and black stripes. Musicians like Peter Gabriel and Youssou N'Dour were immediately enthralled. But her great originality most certainly lies in her interpretation of Dakar's own urban graphics, like the CFA franc and postage and visa stamps.

Pépita D, the talented designer from Benin, approaches the modern by drawing on the symbols of the gods and kings reigning in the ancient palaces of Porto-Novo and Abomey. Dotted with cowry shells or beads, her dresses seem to transform women into eternal priestesses of beauty.

The work of the French-Cameroonians Ly Dumas and Collé Sow Ardo, known as the African Chanel, is seemingly more classical. Both employ traditional fabrics and woven *pagne* waist cloths to create rich and bright, simple and chic designs that link Western

and African fashion. Drawing on his memory of the *ndop* suits worn by the king and other eminent figures from his native country, Ly Dumas claims his work follows in the line of Chris Seydou, his mentor. Adopting his first name as an homage to Christian Dior, a designer who died before his time, Seydou was the first to pave the way for an African fashion that was free of all self-consciousness.

many designers seek to depart from folkloric and ethnic obligations while all the while embracing the rich heritage of African fabric and finery. Such is the case for the enfant terrible of African fashion, the Malian Lamine Badian Kouyaté, better known Xuly Bët, the striking name of his label.

"I want to show the Africa that belongs to Africans," he says simply, referring to the African fantasy evoked by Western designers like Yves Saint-Laurent, Jean-Paul Gaultier, and Paco Rabanne. In Xuly Bët (which in Wolof means "Want my picture?"), you won't find fibers, beads, or raffia. His designs stem from the traditional, but at the same time they are libertarian, unconventional and urban. In 1991, he joined the artist's collective known as the Hôpital Éphémère and toured underground spots for break dancing and rap, befriending forerunners of digital art and advocating practical clothing that was playful and contemporary. He cites his influences as being "the present, the street, everyday life, interior designs, the women and men that I seeing moving about." Basically, everything except museum culture. And it's perhaps this lightness, this off-humor that is so immediately seductive. Youthful and joyously insolent,

Xuly Bët's spring-summer 2005 collection reinvented well-known wax prints. Bright colors, cutting-edge graphics, and pocketbooks with small chains were combined with '50s skirts, androgynous jackets, and skimpy, diva-like dresses. Low-cut tops and swishing skirts were a teasing nod to the traditional African bubu. It's the jubilant opposite of Roberto Cavalli's panther prints and John Galliano's precious Massaï necklaces.

But Xuly Bët doesn't look down on Western designers who draw on the rich reservoir of African tradition. In 1999, the models he chose for his memorable spring-summer collection were given ephemeral markings. It was a brilliant take on tribal mores transformed into an aesthetic canon, reclaimed and adopted as a symbol of boldness and freedom. And at his July 2005 runway show at the Grimaldi Forum in Monaco, his models were coiffed in "rock mains" and dos worthy of Queen Mangbetu of the former Zaire.

"Africa is a melting pot of influences; you can call it 'ethnic'," Xuly Bët says. "But it's also important that this diverse Africa be competitive, a source of inspiration. It creates a positive energy. The setback however is that you don't hear much about African designers."

this is precisely the designer Alphadi's battle. He's an ardent champion of African fashion across the world, striving to come out from under the shadow of future Jean-Paul Gaultiers and John Gallianos in the southern continent. The designer was so driven that not even his strict Muslim family or a brief career in tourism could stop him. In 1998, he founded the International Festival of African Fashion (FIMA),

striving to modernize the image of Africa, to persuade African leaders to found design schools and to simply create a network of designers. It's this crusade that also influences Alphadi's magnificent bustier-dresses that borrow from the materials and skills of the continent. Leather is combined with silver, raw cotton with basin brocade or silk; the Agadez cross and bronze mask-buttons accent proud African women, the original goddesses, who also sport the sophisticated and "wild" jewelry of Mickaël Kra. What art!

Glossary

Brocade Industrial damasked fabric, made from mercerized cotton, woven in Jacquard construction. Produced in Germany and in China, this fabric is cherished throughout West Africa.

Batik Indonesian term designating dyed fabrics with patterns made from wax. Originating in Java, this process has been mastered in West Africa. Batik is a craft in its own right, the skills of which are passed down through the family or apprenticeship.

Bogolan cloth Originally a Bambaran term, which in Mali literally designates a fabric decorated with mud. Woven by men and dyed by women, this cotton fabric can take on a subtle range of colors, from light yellow to black, including all tones of beige and brown.

Camisole Small top, worn with several *pagne* waist cloths and a matching scarf. Taken in with wax or fancy stitching, and sometimes decorated with lace, this article of clothing is found from Benin to the Congo, including in Gabon and the Ivory Coast.

Fancy Appropriated from the English, this term is used to describe a kind of cotton silk screened with rollers. It is very popular in Africa and in Asia.

Indigo Made from indigo tree leaf extract, this dye is used in several African countries, each which gives it its own name, depending on the motifs employed. The number of dye baths and the duration in them will yield an infinite palette of blues.

Ndop Fabric from northwest Cameroon, originating among the Bamum people. Used in the past for rituals and funerals, this royal indigo was revived by the French-Cameroonian designer Ly Dumas.

Ntshak *Pagne* waist cloth once reserved for high-ranking figures.

Rabal This traditional fabric was made by the Manjack in Guinea-Bissau and the south of Senegal (Casamance). Originally made from cotton, it is now blended with raffia (natural or viscose) and silk, and is used for increasingly sophisticated ends. Designers like Oumou Sy, Collé Sow Ardo, and Claire Kane are using it more and more in their work.

Kasaï velvet Cut-pile raffia, this fabric usually incorporates many geometric motifs. It originated among the Shoowa, an ethnic group in the Kuba kingdom in the former Zaire. Intended originally to honor the dead, today it is largely used for fashion accessories.

Wax Developed in the Netherlands in the second half of the nineteenth century, this printing technique, related to Indonesian batik, has become a central element in African clothing. Certain motifs—batteries, fans, flashlights—are purposefully ambiguous, products of urban culture. They also allude to sayings and popular songs.

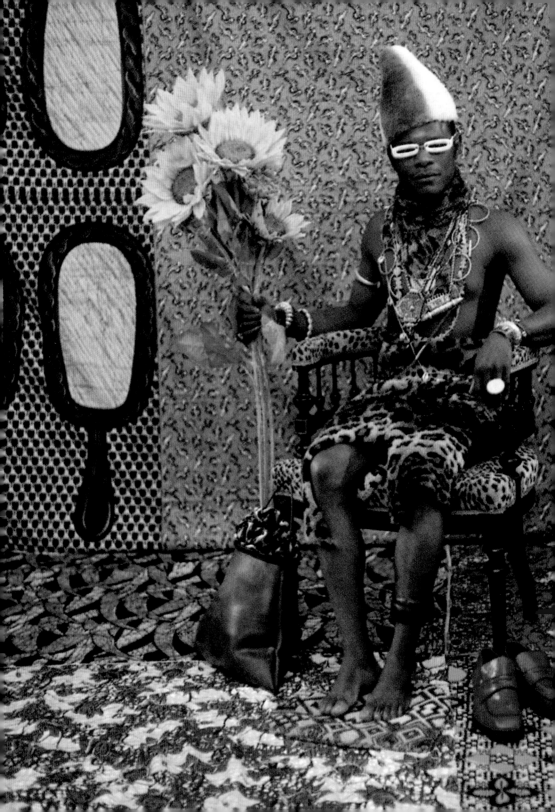

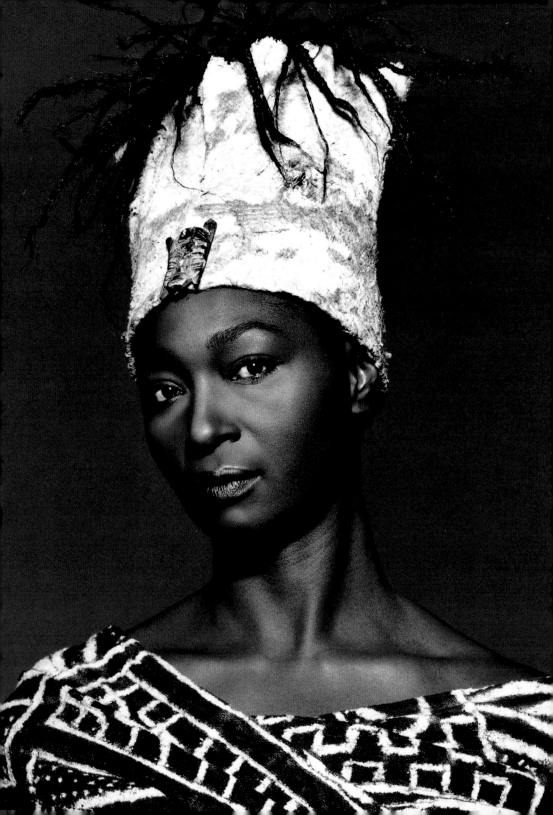

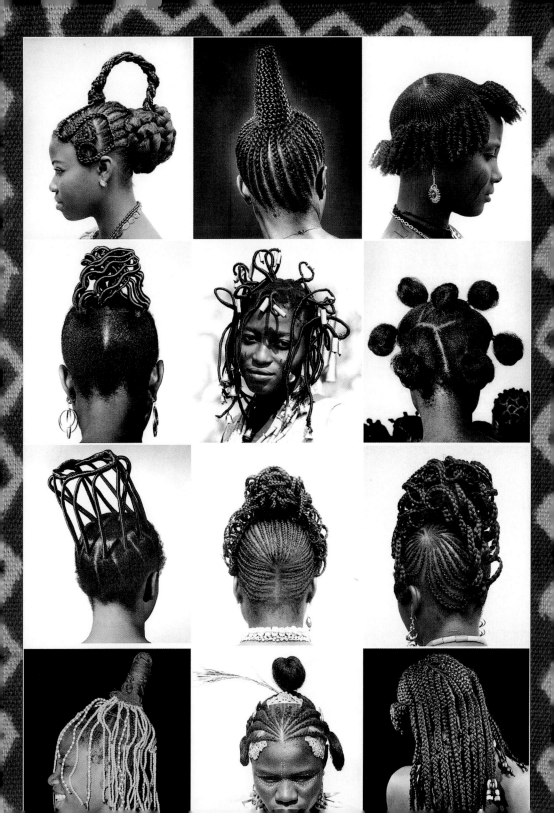

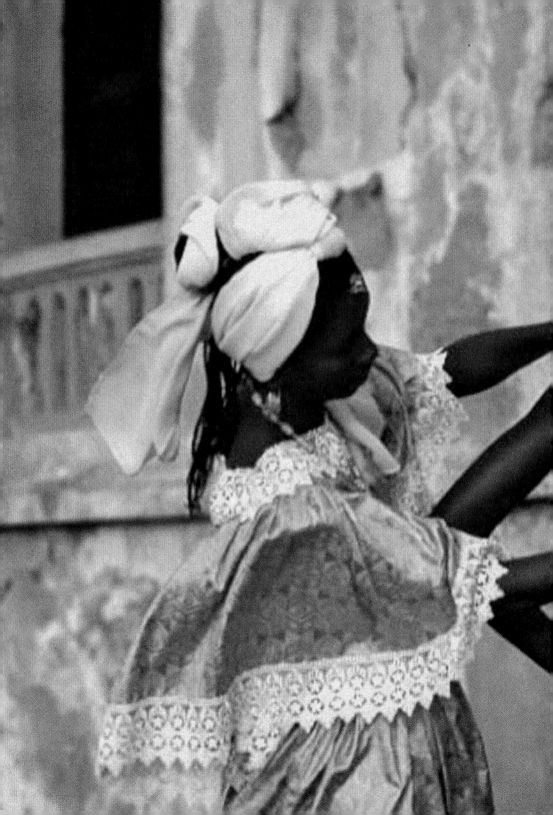

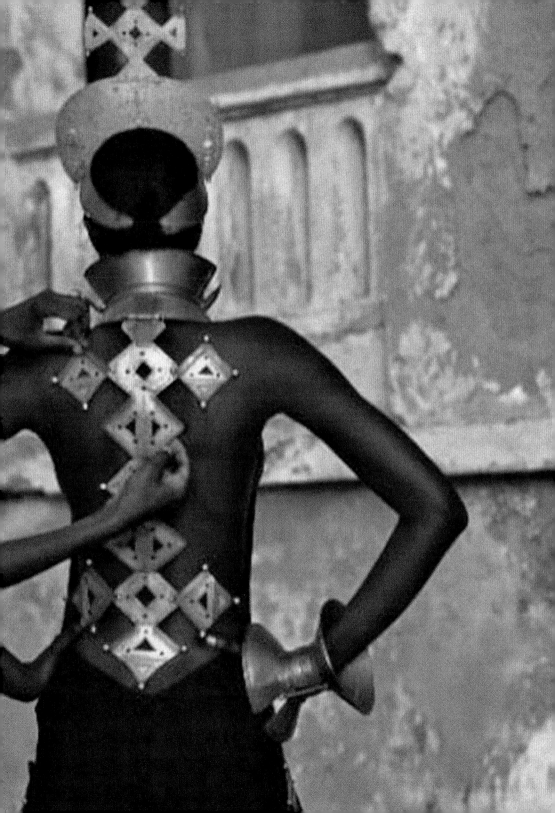

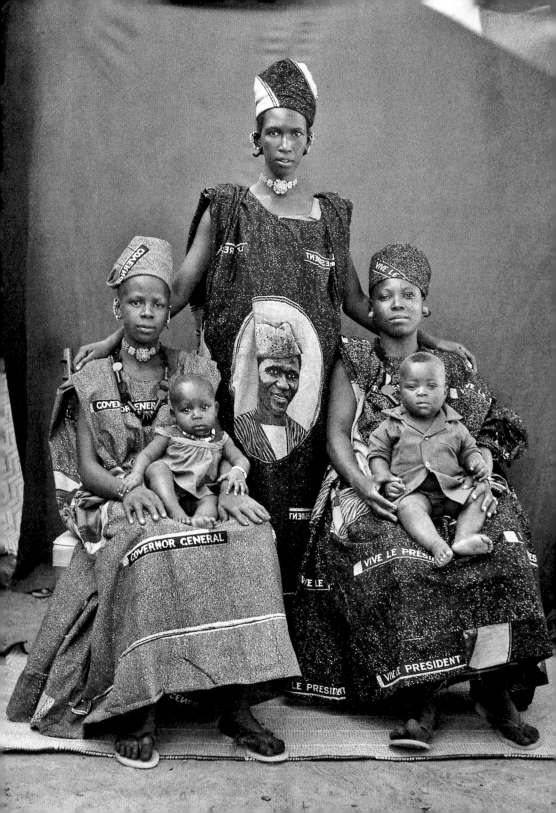

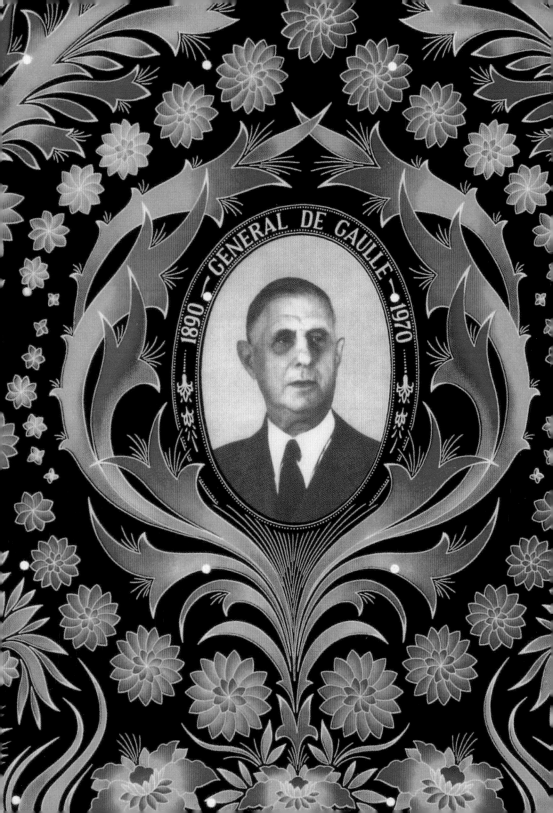

GENERAL DE GAULLE

1890 · 1970

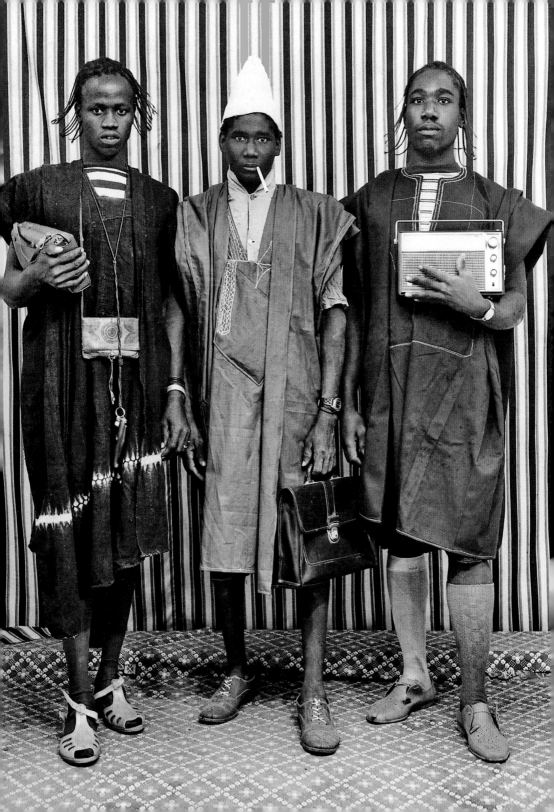

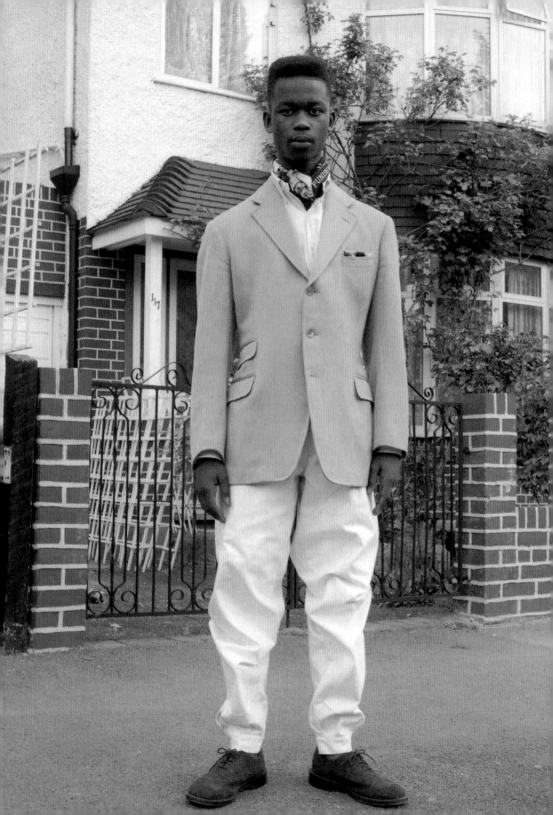

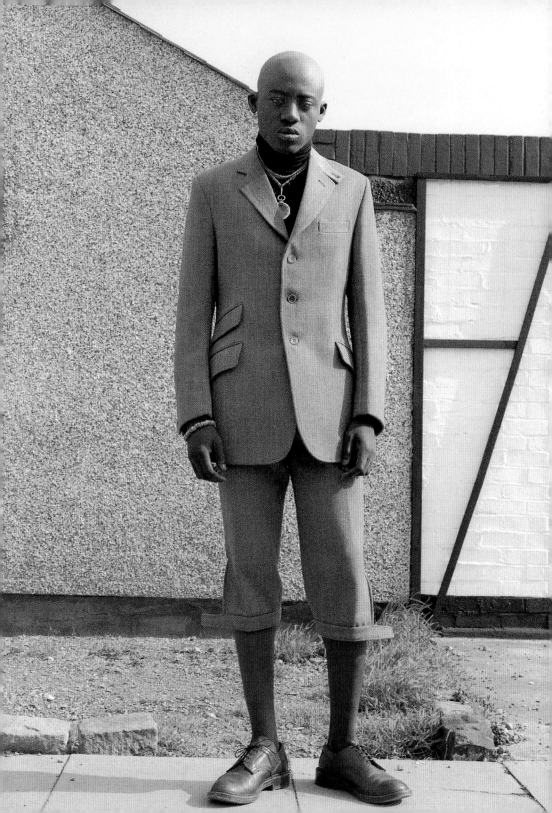

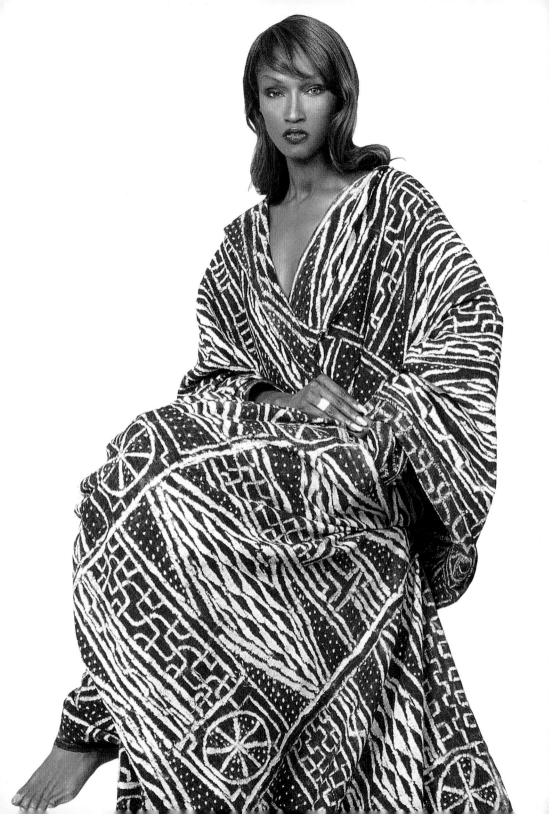

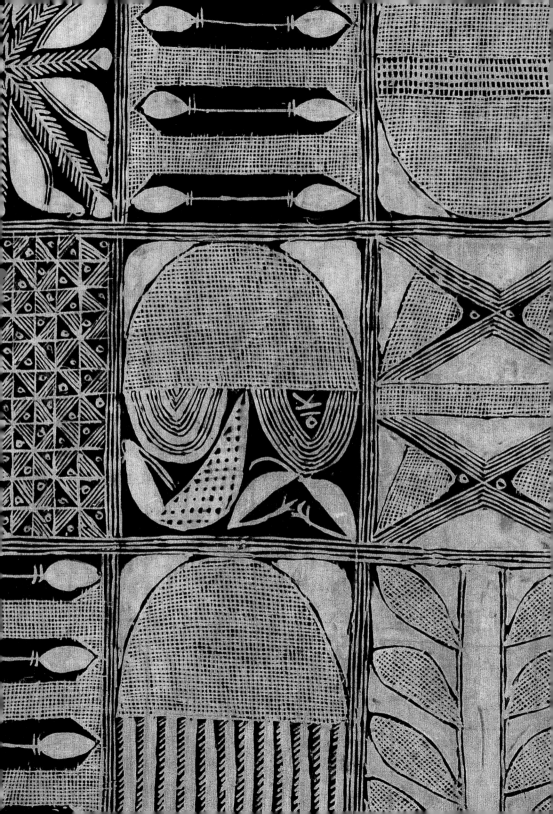

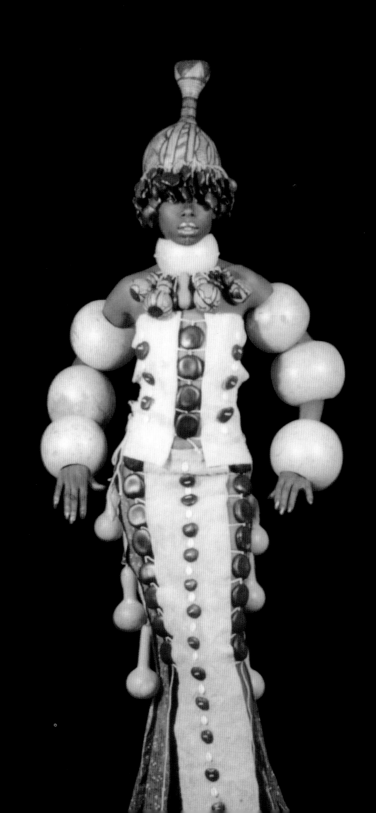

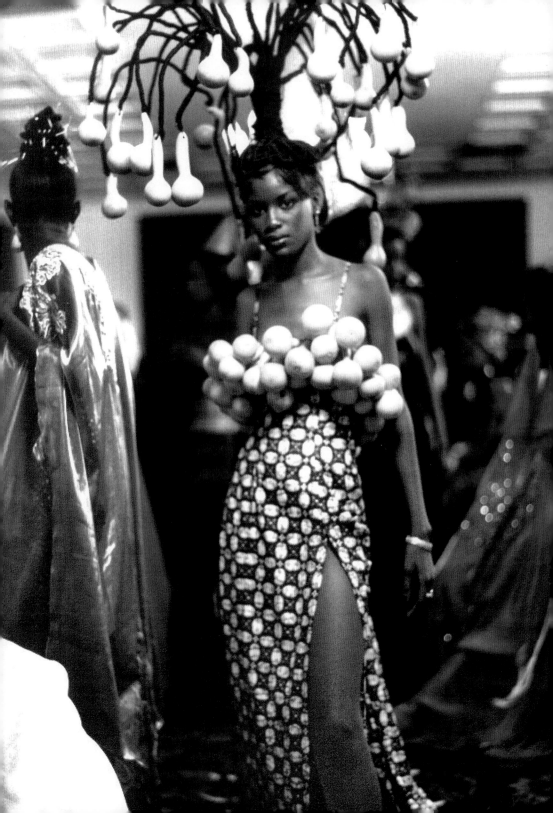

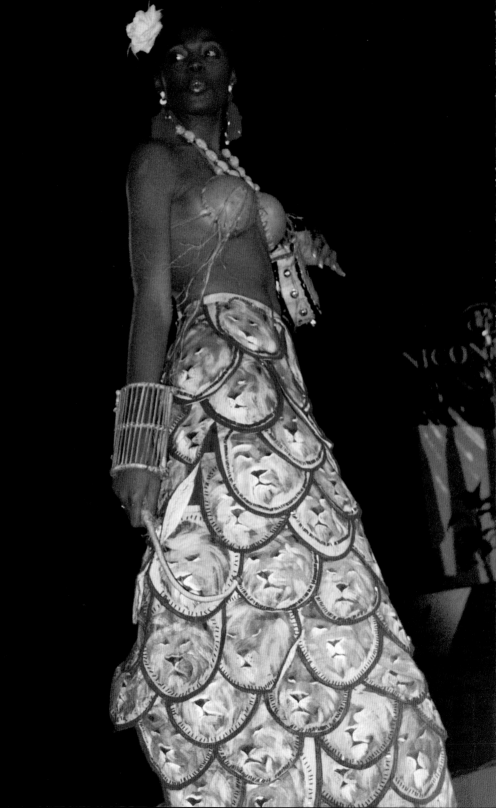

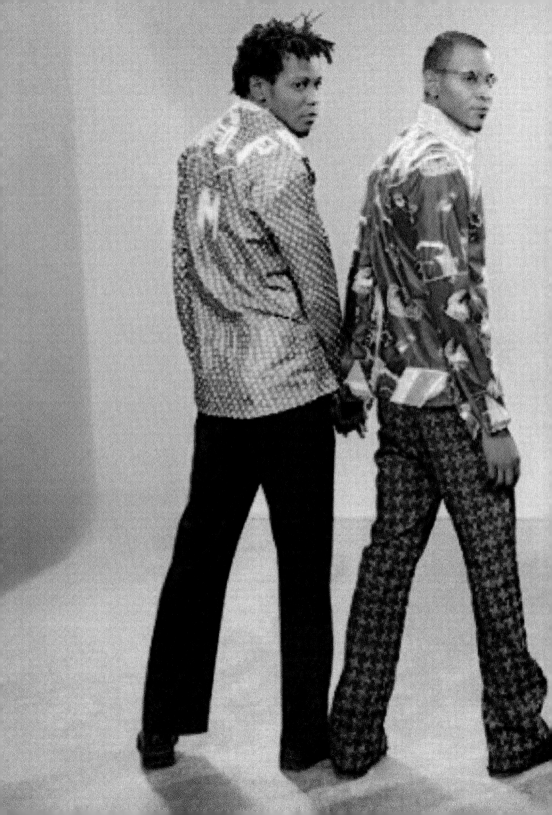

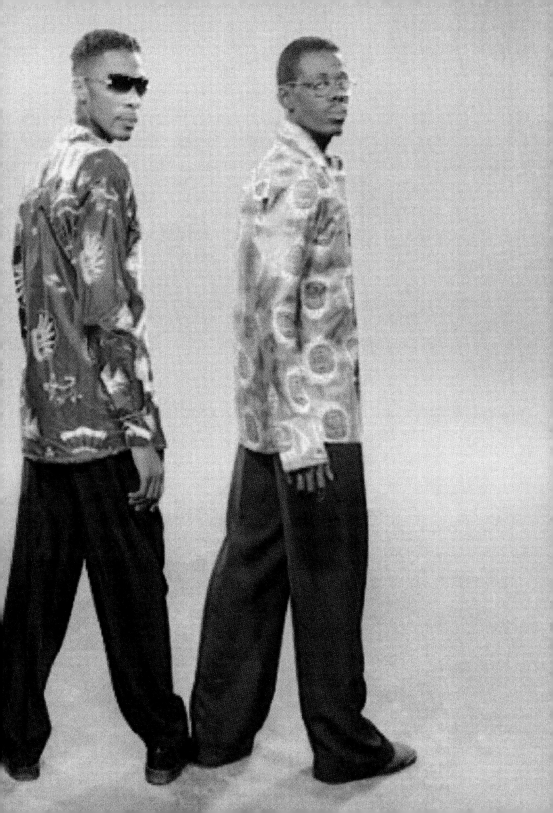

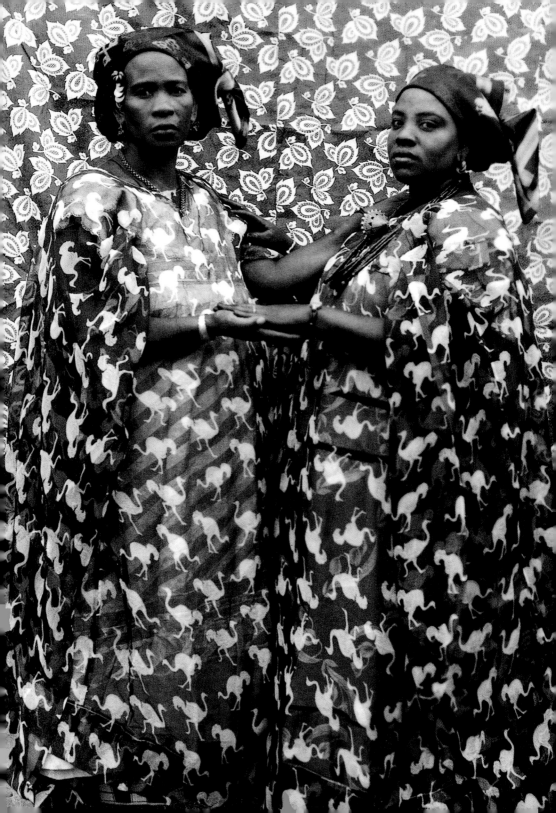

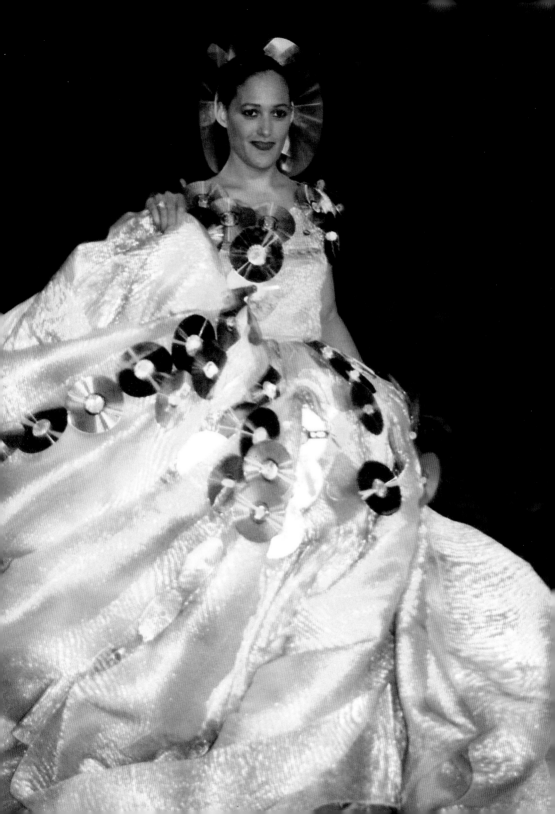

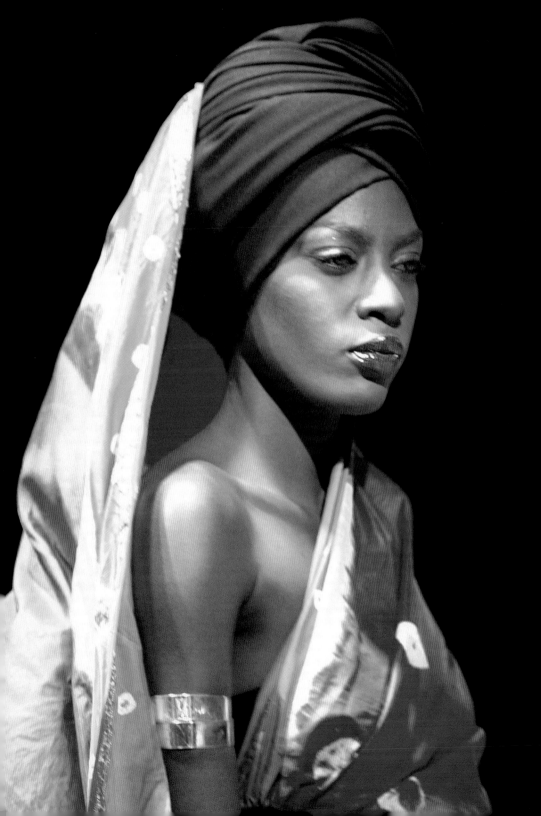

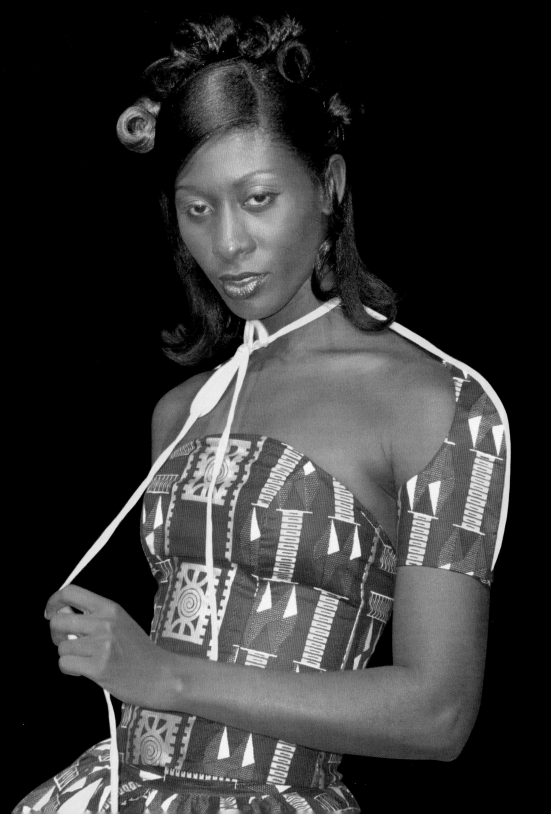

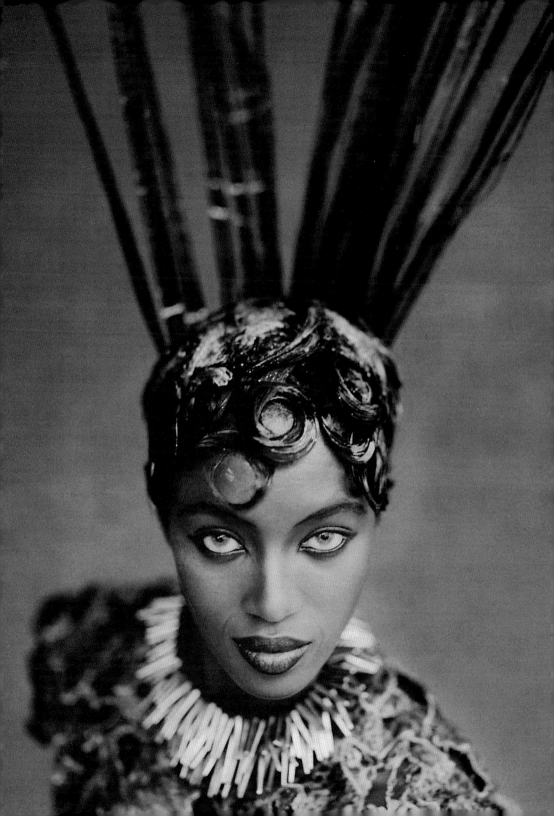

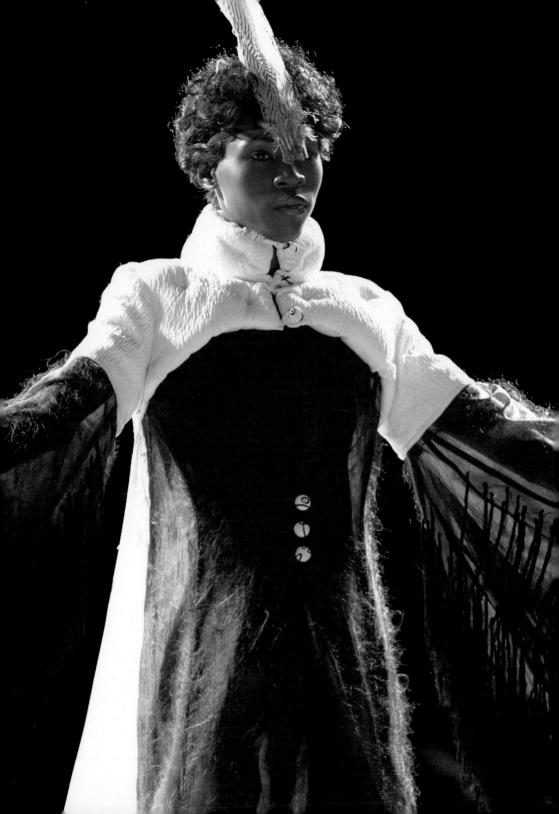

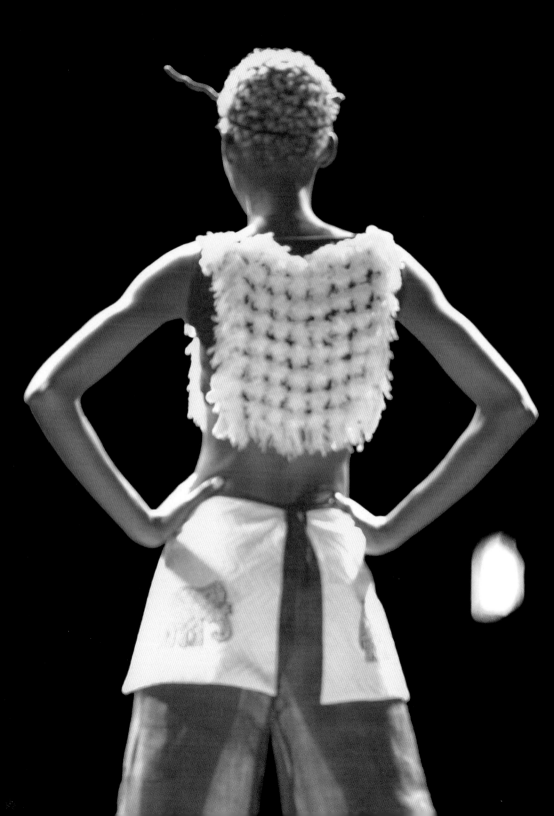

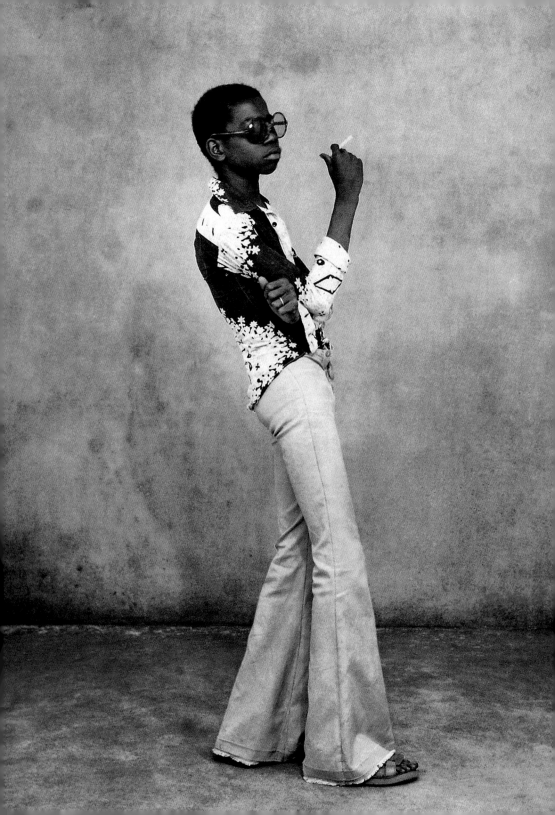

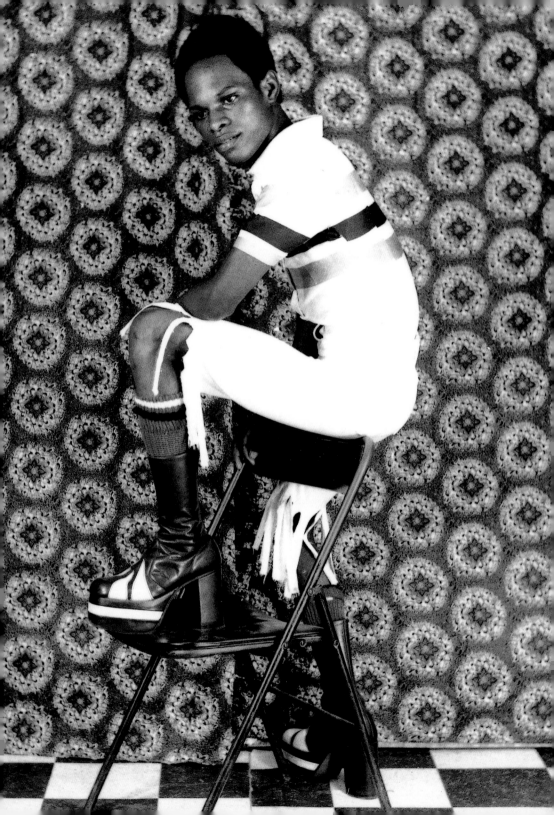

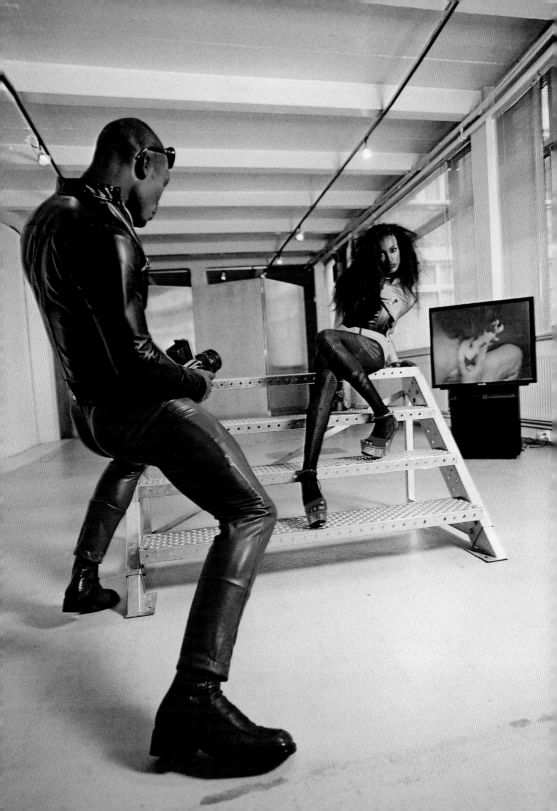

ABSENCE MORALE

VOILA MAINTENANT JE SUIS TRES ALAISE COMME
JE PORTER UNE COURTE VETEMENT SANS SLIP
POUR EXCITER TOUT LE MONDE EN VOYANT MON CUL
LA DEMOCRATIE NOUS FAVORISEES LE CHEMIN, ON
PEUX FAIRE, PARLER NE PORTE QUOI!! JE SUIS LIBRE
IL N'YA PERSONNE QUI PEU M'ARETE.
VIVE LA DEMOCRATURE...

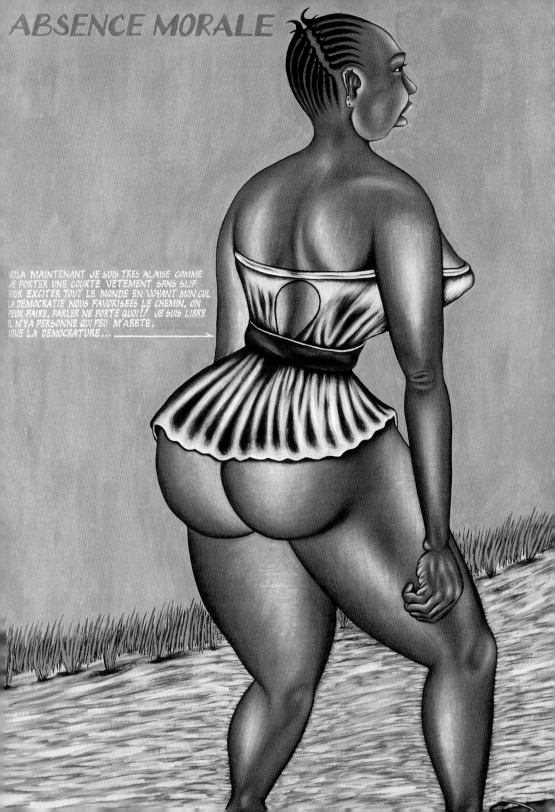

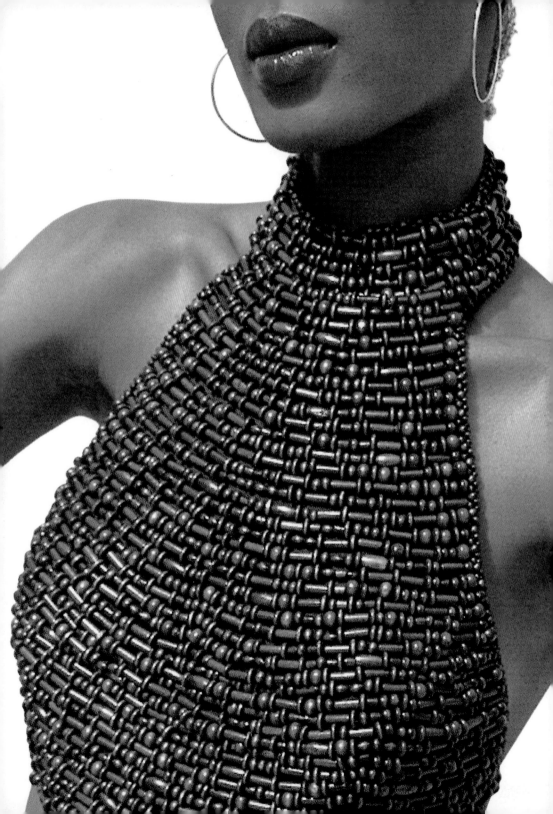

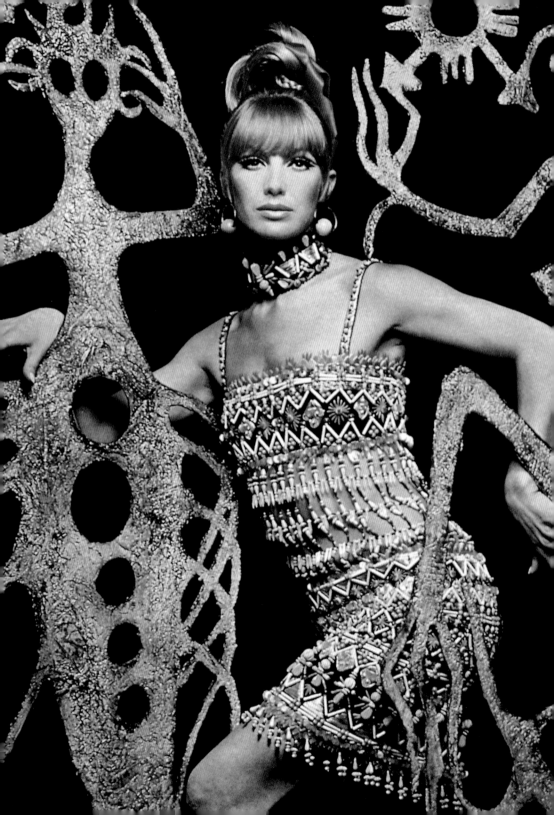

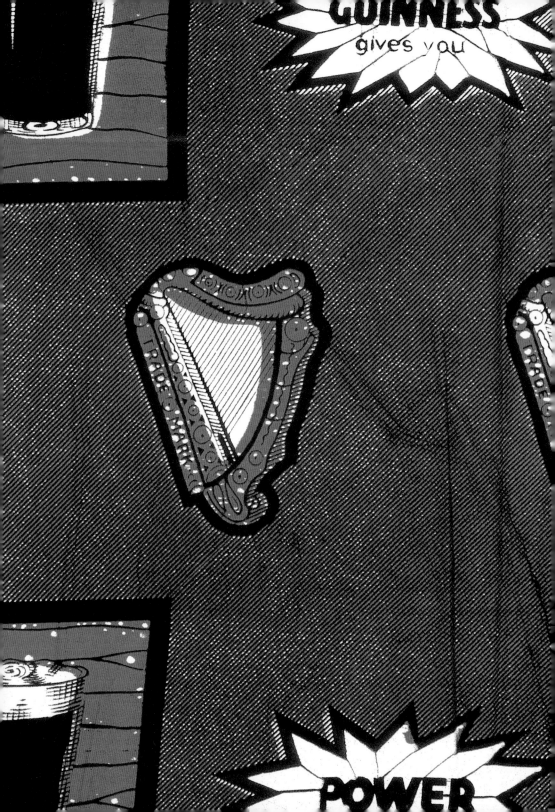

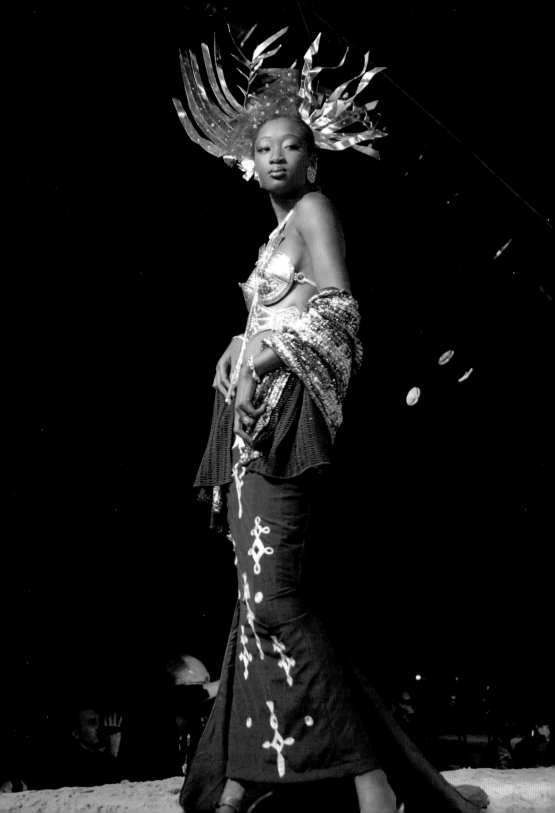

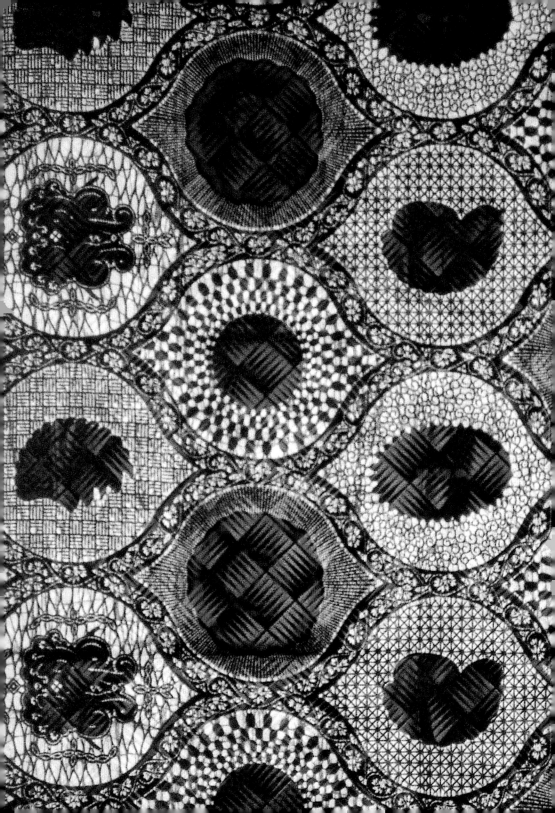

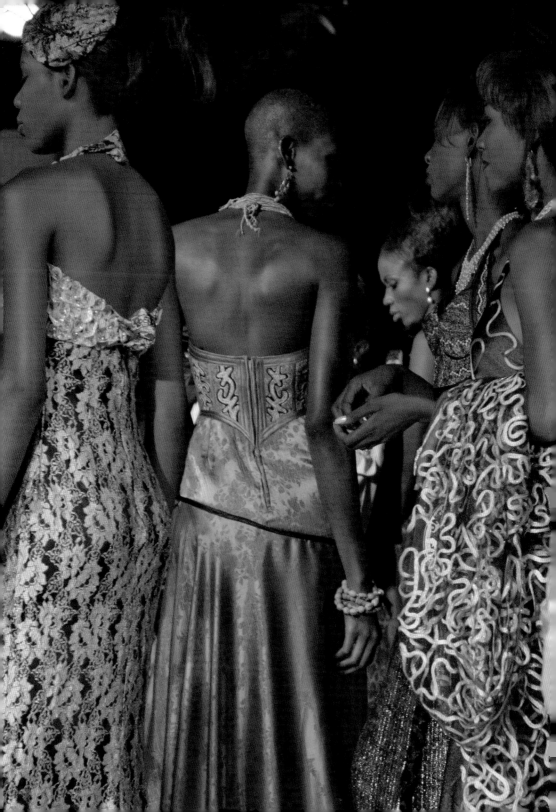

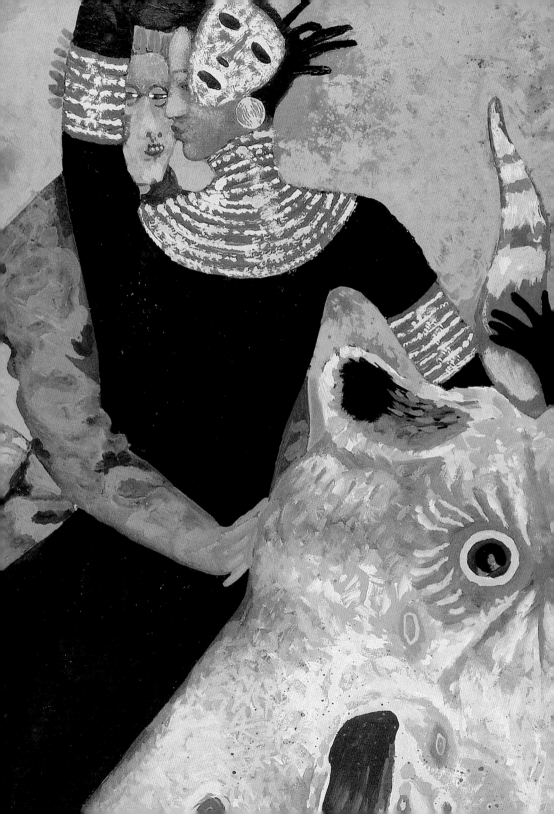

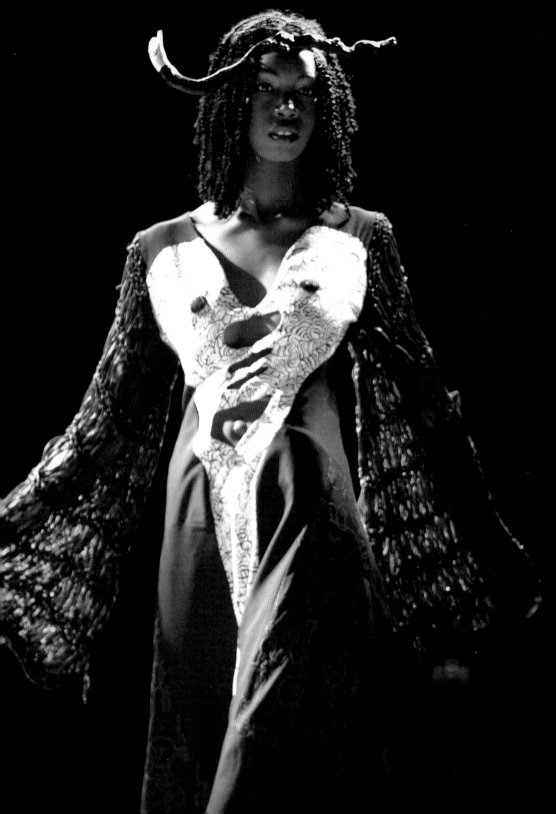

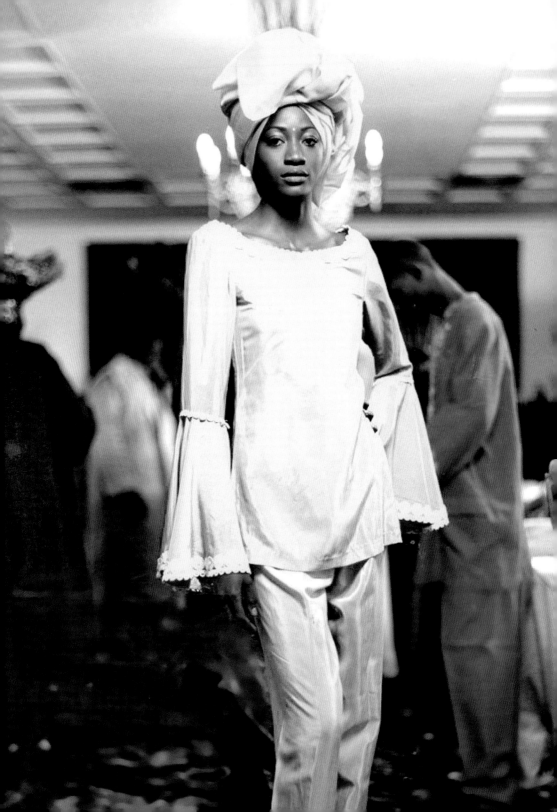

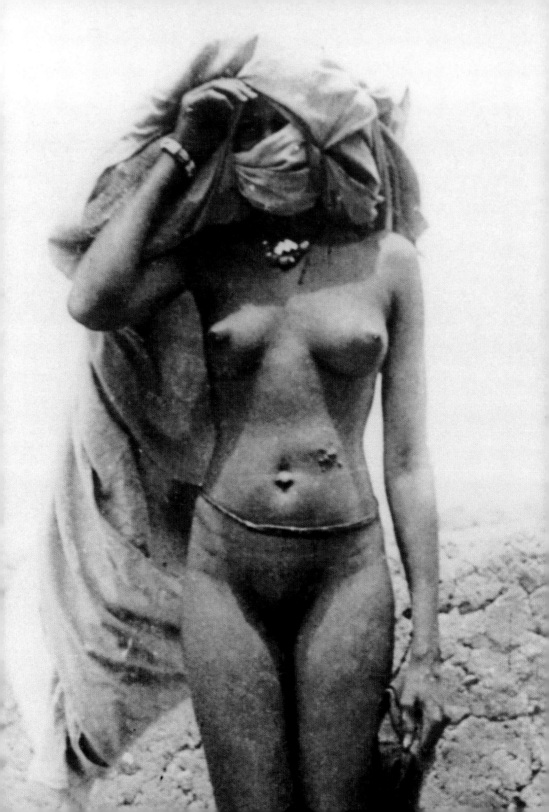

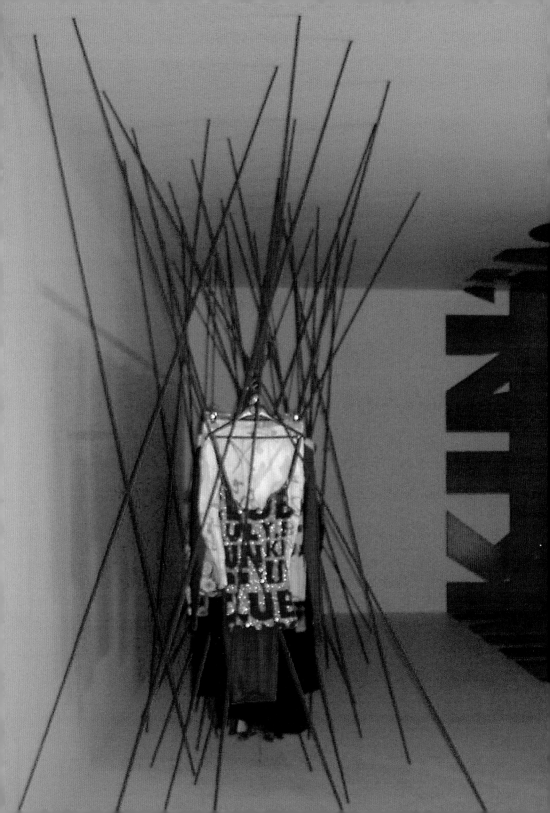

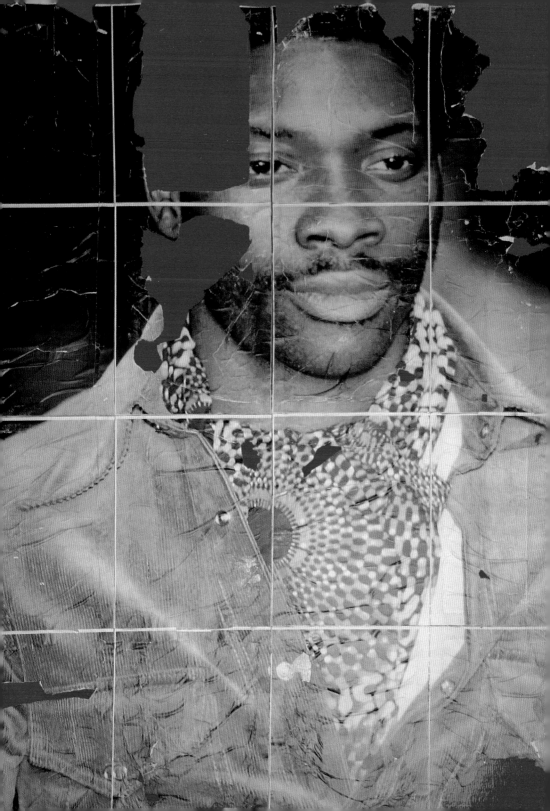

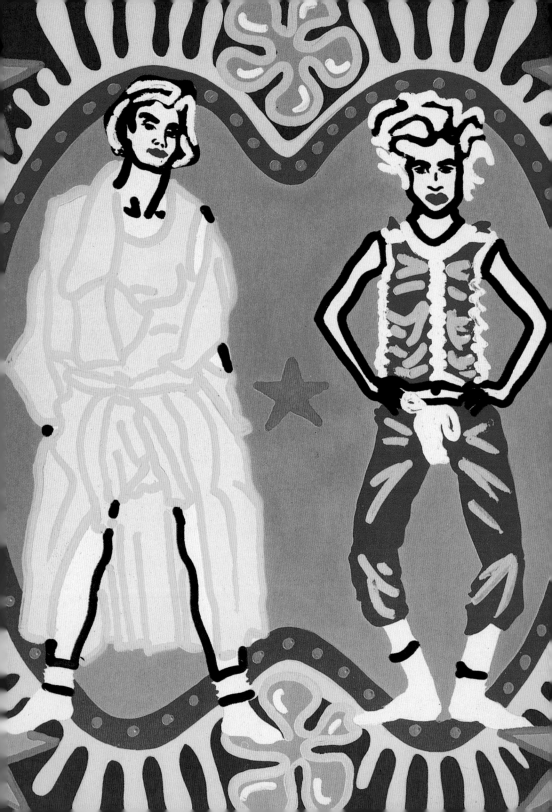

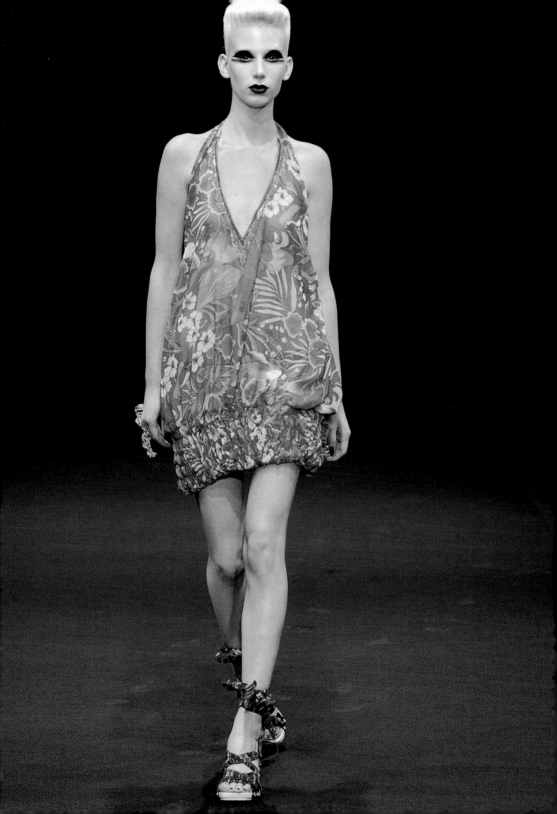

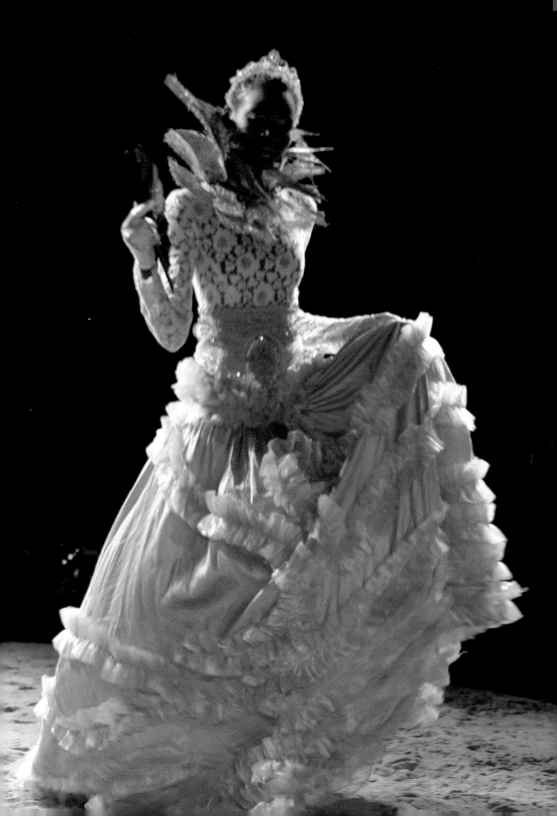

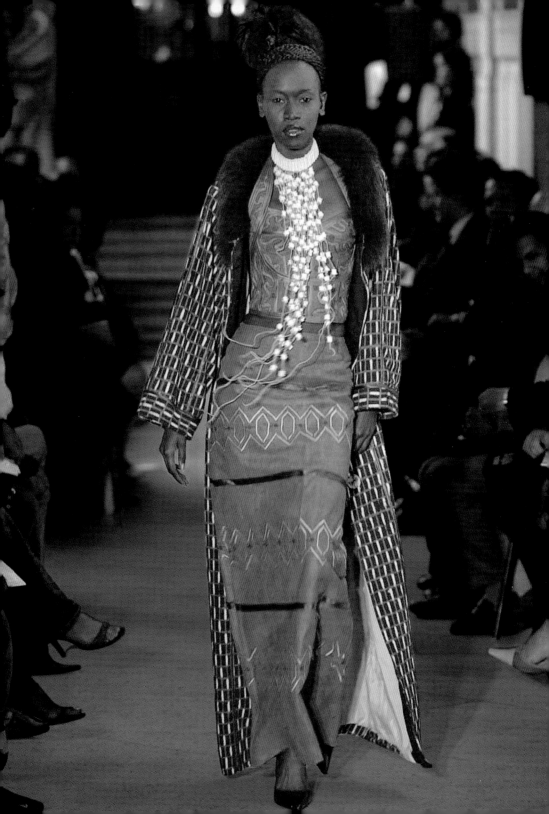

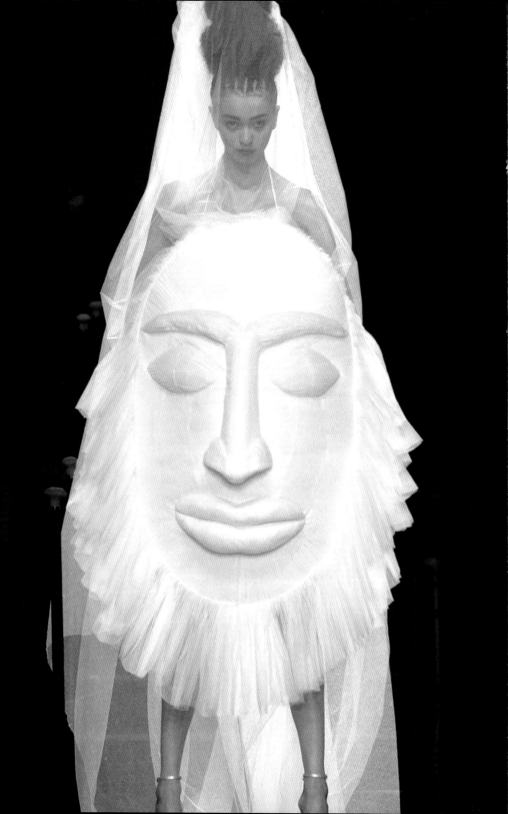

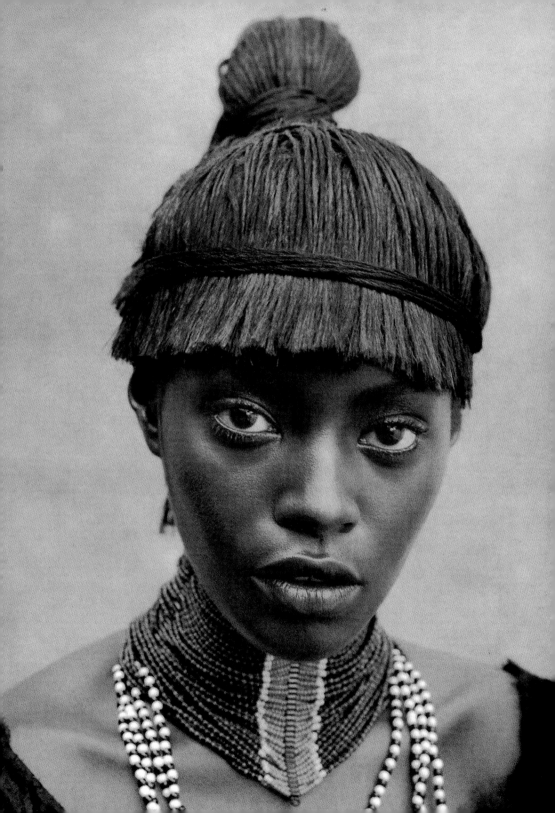

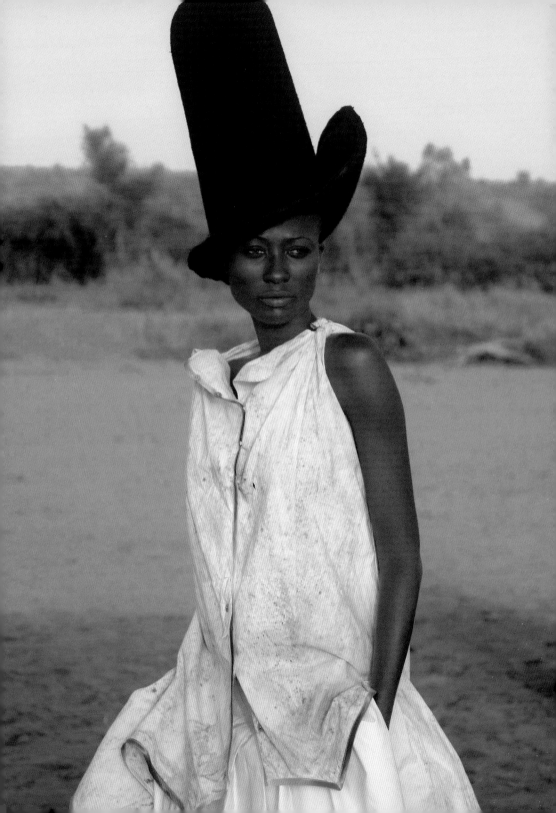

Biographies

Alphadi

Born in 1957 in Timbuktu, this "prince of the desert" represents fashion and the arts in Nigeria today. Although he is loyal to his roots, he is freshly inspired, touching on the traditions and formal vocabulary of the Zarma, Haussa, Tuareg, and Bororo peoples. His greatest source of pride is founding the International Festival of African Fashion (FIMA) in 1998. The event showcases and supports new designers.

Chouchou Lazare

Obsessed with art and inspired by humanism, the Gabonese Chouchou Lazare organized his first runway show in July 1998 as a contribution to the fight against AIDS. The founding president of the Gabon fashion designers guild (UCREATE), he received the top design award in Saint-Étienne, France, in 2002 for his exuberant and sophisticated work.

Chris Seydou

Born in Mali, but an inhabitant of Burkina Faso, Seydou Nourou Doumbia named himself Chris as an homage to Christian Dior, his mentor. He was very young when he discovered fashion, and his designs quickly captivated sophisticated women in Africa. In the 1970s, he moved to Paris, the unrivaled fashion capital. After working for several Paris houses, Seydou became the first African to work in French haute couture. His influence and his spirit can be felt in the other stylists from his continent. Unfortunately, Seydou died at the peak of his career, in 1994, at the age of 44. He had just established the Federation of African Designers in Accra, Ghana.

Collé Sow Ardo

Born in Djiourbel, Senegal, to a father who was a storekeeper and mother who was a dress designer, Aminata Sow entered the world of fashion as a model in 1979. Her passion quickly took hold. After receiving her diploma from the Institut de la Coupe et de la Haute Couture in Paris, she started her own label, Collé Sow Ardo, in Dakar in 1983. Sublimely sober, her mostly two-toned collections are a sophisticated blend of rabal and silk. This "Chanel of Africa" celebrated her twentieth anniversary in fashion in September 2003.

Jemann

With a degree from the École d'Arts Appliqués in Paris, the Cameroonian Jemann returned to his country in 1980. There he quickly established a clothing company in Douala that functioned with some fifty machines. He also heads a training center for designers in Yaoundé and Douala. His singularly inventive designs have since received support at every major rendez-vous of African fashion, including FIMA, KORA, the Night of African Fashion, and others.

Juliette Ombang

Already obsessed with fashion at the young age of 11, the Cameroonian Juliette Ombang fights for African fashion, not only through her Black Giraffe label, but also through her prêt-a-porter salon, which she founded in Yaoundé in 2002, the Yaoundé Fashion Week. Inspired by various designers, like Versace, Ungaro, and Valentino, the dynamic designer also brilliantly draws on traditional raw materials (raffia, linen, cotton, *ndop*, and others) to create designs that abound in color.

Ly Dumas

Born among traditional fabrics, celebrations, and ceremonial rituals, the Cameroonian Ly Dumas introduced an image of Africa that is proud of its textile heritage, of its magnificent beadwork and its indigo. After several fiery collections and a moving runway show that accompanied the exhibition *Le Boubou: C'est Chic* at the Musée des Arts d'Afrique et d'Océanie, she now devotes her time to humanitarian causes in her native country.

Sakina M'sa, PE 04 Collection, FIMA 2003 in Niger. Matured cotton tunic and stich top hat. A plastics technician designer, this young creator from the Comoro Islands develops an experimental research through deconstructed creations, straddling two cultures. With Vivienne Westwood, Sakina M'sa presented her Fall-2003 fashion show in Berlin. © Karim Ramzi.

Mickaël Kra

Born in France but raised in Abidjan, the Franco-Ivorian Mickaël Kra has always touched on both his cultures, creating luxury accessories and jewelry that have captivated the greatest designers around the world. He has worked in haute couture for French designers like Louis Féraud, Pierre Balmain, and Jean-Louis Scherrer, as well as for African designers like Alphadi. Today his work is geared toward his *"petite couture"* collections, like his magnificent line made from leather beads and Ostrich eggs, inspired by the skills of the San women in Kalahari.

Oumou Sy

Born in 1952 in Podor, Senegal, the sublime Oumou Sy is a fairy-tale character. A child of small build, with a protective father and a quasi-divine mission, this self-taught designer has turned into one of the greatest contemporary fashion visionaries through her strength and energy. Her amazingly modern dresses are chromatically bold and bear names like Calabash, Baobab, and Palm. Founder of a school for designers, Oumou Sy also runs an Internet café in Dakar with her husband, Michel Mavros, called Metissacana.

Pathé'O

Born around 1950, Pathé Ouédraogo spent his childhood in a village in what is today Burkina Faso. In 1977 he opened his first studio in the heart of the Treichville neighborhood in Abidjan. A few years later, he founded the Pathé'O label, which enjoyed success among politicians, including Nelson Mandela. Modernized bubus and woven *pagne* waist cloths filled with fantasy distinguish this productive and great designer.

Pépita D

Pépita Djoffon, from Benin, belongs to the new generation of young designers who dare to skillfully combine European and African influences. This brilliant graduate of ESMOD opened her first boutique in Cotonou. The orders were quick and abundant, and the young stylist now participates in many international salons. Her signature is a remarkable combination of traditional fabrics and contemporary cuts, using symbolic motifs.

Xuly Bët

Born to a Senegalese mother and a Malian father, Lamine Kouyaté was exiled to a Paris suburb, Argenteuil, after a military coup. Having earned a degree from the Dakar École des Arts, he began studying architecture in France, but stopped after five years; the designer claims to "prefer fabric to concrete." As early as 1989, he established his Funkin' Fashion Factory in the official squat of the Hôpital Éphémère in Paris. This humane and artistic adventure would forever mark him. With his Xuly Bët line (in Wolof, the phrase means "Want my picture") he creates sophisticated clothing that is playful and timeless, and that departs from the clichés normally associated with African fashion. As if he were a musician, his world hovers between rock and jazz, against a background of urban graffiti.

Bibliography

Coquet, Michèle, *Textiles africains*, Adam Biro, Paris, 1993.

Gardi, Bernhard, *Le Boubou: C'est Chic*, ed. Museum der Kulturen, Christoph Merian Verlag, Basel, 2002.

Geoffroy-Schneiter, Bérénice, *Ethnic Style*, Assouline, Paris, 2001.

Gillow, John, *Textiles africains*, éditions du Regard, Paris, 2003.

Grosfilley, Anne, *Afrique des textiles*, Edisud, Aix-en-Provence, 2004.

Mendy-Ongoundou, Renée, *Élégances africaines*, éditions Alternatives, Paris, 2002.

Revue noire, special fashion issue, N° 27, Paris, Dec.1997–Jan.-Feb. 1998.

Beyond Desire, exhibition catalogue, Musée de la Mode, Anvers, éditions Ludion, 2005.

DD Funk warning 11, by the French-Congolese photographer Patrice Félix Tchicaya.
© Patrice Félix Tchicaya.

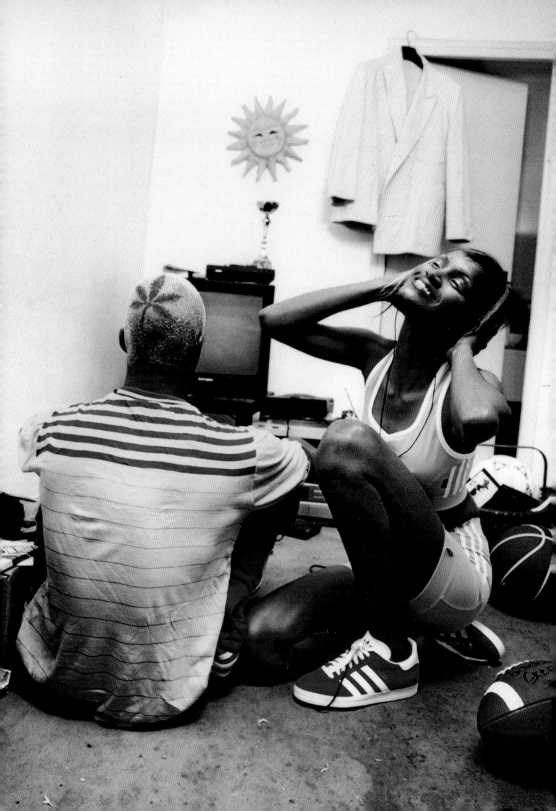

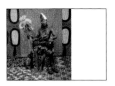

Samuel Fosso (Cameroon), *The leader who sold Africa to the colonists*, from *Tati: Self-Portraits*, 1997, 39^1/3^ x 39^1/3^'', Musée National d'Art Moderne, Paris. The self-portrait is very rare in Africa. The Cameroonian Samuel Fosso approached this form using a sometimes serious, sometimes comical tone. Here he presents himself as an "African-style" ruler, wearing animal hides and waving sunflowers, mockingly holding a scepter. With gracious permission from Jean-Marc Patras. © Samuel Fosso.

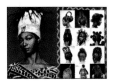

Portrait of Ly Dumas. The spiritual offspring of the great Chris Seydou, the Cameroonian designer. Ly Dumas has an insatiable appetite for traditional fabrics like *ndop*, *rabal*, and Kasaï velvet. Working with the painter Eddy Saint-Martin, she even launched a line inspired by the Bamum alphabet invented in the nineteenth century in Cameroon. © Henri Roy J. D.
Okhai Ojeikere, *Hairstyle*, 1968–1975. Both an artist and an ethnologist, the Nigerian photographer Ojeikere captured the ephemeral creations that are African "hair sculptures" © C.A.A.C., Pigozzi collection, Geneva.

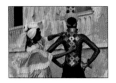

Oumou Sy, *Enveloppe du désert [Desert Coil]*, June 2000. The Senegalese designer Oumou Sy is famous for her exuberant designs and her extensive work for theater and film. The artist is distinguished by sophisticated hairstyles, jewelry inspired by nomadic populations like the Tuaregs, and her experiments with materials. © Christophe Lepetit.

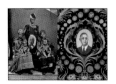

Malick Sibidé, *Sarakole family at the Mission of Bamako*, 1962. Having earned a fine arts degree from Bamako, the Malian Malick Sibidé opened a photography studio in 1958. Filled with tenderness, his group portraits reflect modern Africa, touching and filled with contrast. His international fame in the 1990s put him in the spotlight, propelling him to go down new roads. © Malick Sibidé. **Wax textile**, Vilsco Museum, the Netherlands. There's nothing more joyful, more jubilatory, than the commemorative bubus worn by African women during parades or visits by political leaders. © Tim Stoop.

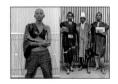

Cheikha Bamba Loum, Sigil collection. The happy winner at the last Dinard International Fashion Awards, the Senegalese Cheikha Bamba Loum has developed a sophisticated style that challenges "ethnic" clichés all too often associated with African fashion design. He brings together jean with traditional embroidered motifs, as an example. © Dominique Laugé.
Malick Sibidé, three Fulani Shepherds, 1976. The richness of this shot lies in the subtle combination of the traditional (costumes, caps), and the modern (cigarettes, transistor radio, and sandals) © Malick Sibidé.

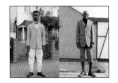

Simon Foxton, *Strictly* collection, 1991, Beyond Desire exhibition at the Museum of Fashion (MoMu), Antwerp. SAPE, four letters that alone define a spirit, a dandyism, and a social revolt. At the end of the 1970s, at a time of economic recession and unemployment, "la Sape" took shape in the streets of Congo-Brazzaville. French slang for "well-dressed," it was also an acronym for "*Société des ambianceurs et des personnes élégantes*" (club of ambiance givers and elegant persons). For a *sapeur*, there was one golden rule: blow away, fascinate, obtain objects of desire, be a walking model of the latest looks. © Jason Evans.

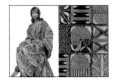

Superb *ndop* from Cameroon, left (c. 1950, Galerie Towa collection, Paris. © All rights reserved.) and **Adire fabric** from Nigeria, right (© All rights reserved.). Many designers seek to reclaim African fabrics, following the lead of Chris Seydou, who introduced bogolan cloth in his work. This involves rethinking notions of elegance by decontextualizing and revisiting a rich heritage of textiles once reserved for traditional use. Just as Sy Dumas researched the many usages of *ndop* by Cameroonian rulers, the Ghanaian Kofi Ansah transformed the kente fabric used by Ashanti leaders into cocktail dresses.

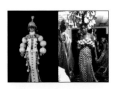

Anggy Haif, left (Cameroon, Abbiala dress: top and fish skirt with panels made from hand-dyed cotton and obon–tree bark fabric, with Abbia ornaments, cowrie shells, and calabashes, FIMA 2003 in Niger. © All rights reserved.) and **Oumou Sy,** right (calabash dress, 1998. © Christophe Lepetit.). Boldness, humor, and inventiveness are among the qualities that many African stylists possess. They draw from materials that are emblematic of their heritage. Here the woman becomes a fantastic creature, half-goddess, half-plant. The great filmmaker Pasolini, who created a staggering Medea, would have undoubtedly loved these theatrical and poetic outfits.

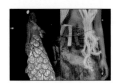

Joseph Adebayo Adegbe (Nigeria), among the contestants in the competition organized by AFAA ("L'Afrique est à la mode"—"Africa is in style"), during FIMA 2005. He proudly wears a richly colored wax dress that nevertheless retains a modern feel. The calabashes used as a bra are a good-natured nod to tradition as well as to cliché. © All rights reserved.
Bill Ruterana (Rwanda), a contestant in the same contest. The candidacy of the young Bill Ruterana blew away the selection committee with the chromatic splendor of his materials, including plant fiber and raffia, which could have been used by Kenzo or Galliano. © Gill Tordjeman.

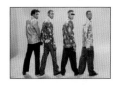

Gabriel Ramazani-Amundala (Democratic Republic of the Congo), 2004 collection. New young African designers draw on humor and casual looks, hoping to escape the suffocating iron collar of tradition. These models wearing bright colored shirts have a show-off air without being arrogant. The models of the young Congolese designer Gabby Amundala enjoyed great success at the last Design Biennial in Saint-Étienne. © All rights reserved.

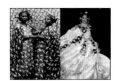

Seydou Keïta (Bamako), 1959. All of Bamako posed for the inspired Keïta. The great photographer, who died in 2001, left countless, sumptuous images that have earned him international fame. Standing in front of a patterned piece of fabric, two elegant men are here transformed into icons. © C.A.A.C., Pigozzi collection, Geneva.
Oumou Sy, *Cyber dress,* presented at International Fashion Week in Dakar in 1997. The "Magician of Dakar" can be subversive. With this spectacular Cyber dress, she speaks out against consumerist society. © All rights reserved.

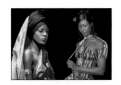

Paul-Hervé Elisabeth (Martinique), FIMA 2003 in Niger. Born into a people composed of many cultures, this West-Indian designer considers Africa "as a real laboratory" since he discovered Mali in 1998. He attemps then to recreate icons, in order to recall that Africa is not only inhabited by slaves, but also by princes, hunters… © Karim Ramzi.
Sapho (Ghana), dress using basin brocade, raffia and the sacred forest (kola and mud). During the last FIMA (2003), the Ghanaian de-signer Sapho ingeniously combined time periods and continents, creating "African Cinderella" dresses that were both original and poetic. © Karim Ramzi.

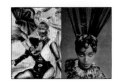

Haute couture, winter 1984–85. Iridescent leather hat by Pierre Cardin and asymmetrical dress made from crepe, black silk, and white duchesse satin by Jean Patou. Well before John Galliano's Yoruba hat for Christian Dior (summer 1997), Pierre Cardin was playing off of African headgear. At his last runway show (summer 2005), Jean-Paul Gaultier gave his own take on this "hair" material. © Helen Tran.
Naomi Campbell. Interpretation of a pointed-braid hairstyle in fashion in Burkina Faso. Hairstyles in Africa have always indicated ethnicity and are now richly reinterpreted. © Paolo Roversi.

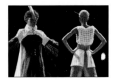

Nadège Cezette (Martinique), FIMA 2003 in Niger. Born in France to a father from Martinique and a French mother, this young, inspired designer loves cloth, folk art and African art. When he discovered the work of painter Guillaume Nicalaou, he inventively began drawing on myth and various materials. © Karim Ramzi.

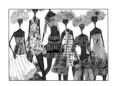

M^{elle} Asha (Mozambique), in the competition organized for the AFAA ("L'Afrique est à la mode"), during FIMA 2005. There aren't many African designers who learned to use a pencil before a pair of scissors! The drawings of this young designer are strikingly confident and modern. © All rights reserved.

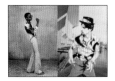

Malick Sibidé, 1963. This young dandy from Bamako seems to be showing off, but not without humor. He stylishly sports his bellbottom pants, his sunglasses and printed shirts. It's all of 1960s rock-and-roll in one form. © Malick Sibidé.
DD Funk Warning 4 (A Gangster Tale...) by the French-Congolese photographer Patrice Félix Tchicaya. Working with the Sierra Leonean designer Raymond Cole, this fine art photographer claimed African fashion (Xuly Bët, for example) to create his Black Urban Culture series in the 1990s. © Patrice Félix Tchicaya.

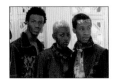

Cheikha Bamba Loum, *Sigil* collection. The young Senegalese designer is directly influenced by his predecessor, the avant-garde Xuly Bët. He, too, experiments with materials (embroidered jeans) and has a social mission to desegregate African fashion and liberate it from its clichés. It's all about urban integration. © Dominique Lauge.

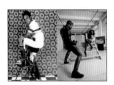

Samuel Fosso, *Self-portrait*, 1977. Both narcissistic and painfully introspective, Samuel Fosso's self-portraits betray the extraordinary care usually taken to select clothing and decor. © Samuel Fosso.
Blow Out 5 (Blue) by Patrice Félix Tchicaya. Another glimpse at the work of this French-Congolese photographer. He has been published in numerous magazines and has exhibited in Bamako at the fifth biennial of African photography. This image is among those in the private collection of the Maison Européenne de la Photographie. © Patrice Félix Tchicaya.

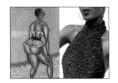

Cheik Ndoluvualu, known as Cheik Ledy (Democratic Republic of the Congo), *Absence Morale*, 1990, oil on canvas, 60 x 53". Shocking or humorous? Both, most likely. These ample figures can't be contained by a corset. © Cheik Ndoluvualu.
Julian Smith, Top made entirely from wooden beads. For almost twenty years, this South African designer's work has been sober and structured. He often incorporates his favorite materials, beads. The career of Julian Smith has since gone international, with orders coming from the United States. © All rights reserved.

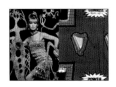

Yves Saint-Laurent, African collection, summer 1967. Reflecting an Africa based more in fantasy than reality, this minidress, made entirely of beads, hints at a partially uncovered stomach. It's the height of sexiness at a time when France tended to be discreet. © Photo Guegan/L'Officiel.
Cotton printed with the Guinness logo, Manchester, 1961. Even more than in Europe, clothing in Africa is a great communicator. The range of motifs from abroad, like this beer logo, sometimes seems out of place in Africa. © All rights reserved.

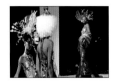

Alphadi (Niger), FIMA 2003 in Niger (left: © Patrice Félix Tchicaya; right: © Karim Ramzi). Seidnaly Sidahmed is better known as Alphadi—or "the prince of the desert." The flamboyant nickname was given to him by the press. His extremely sophisticated collections are grounded in traditional skills. Hand embroidered, decorated with beads, these bustier-dresses reach rare classic heights. Since 2001, he has been exploring new materials, like raffia and even tree bark.

78

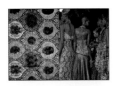

Cotton printed with embroidery motif, A. Brunnscheweiler & Co., England, c. 1990. A social language that speaks of the person who wears it, hair lends itself to all metaphors. Such "capillary grammar" is found on this handsome fabric printed in England. © All rights reserved.
Alphadi, FIMA 2003 in Niger. Named a goodwill ambassador and honored with distinction in France in 2001, Alphadi founded FIMA in 1998 in order to bring together African designers and to fight for international recognition. © Karim Ramzi.

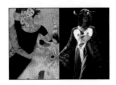

Karl Lagerfeld, georgette crepe dress, golden mask and snake locks, summer 1984. Sophisticated and clever, Karl Lagerfeld's African designs have hints of Art Deco. They seem barely related to the experiments of designers like Gaultier or John Galliano. © Anton Solomouka.
Nadège Cezette, FIMA 2003 in Niger. This collection is worthy of a children's fairy tale. The absence of color is intentional. The shapes speak for themselves and immerse us into a poetic, unusual world populated by dreamlike creatures. © Karim Ramzi.

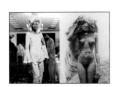

Alphadi. For this designer, his roots in the Sahel grasslands are an endless source of inspiration. He draws on the skills of the Fulani, Haussa, and Tuareg peoples, thus bringing together traditional and modern Africa in the name of harmony. © Patrice Félix Tchicaya.
Sudanese woman. Turbaned woman, veiled woman. There are so many faces in Africa, all representing a continent pulled toward its past and its present. Today haute couture is attempting to free itself from the stranglehold of certain voices. In some circles, runway shows are considered a disgrace to modesty and dignity. © Lucien Crouzet/All rights reserved.

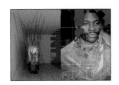

Xuly Bët, detail of his boutique *Funkin' Fashion Factory,* left (installation for the MoMu in Antwerp, 2005) and **poster for his fall-winter fashion show in New York 1999,** right (© Jérôme Clermont). Born in 1962 in Mali, Lamine Badian Kouyaté launched his Xuly Bët label in Paris in 1989. His work leaves African folklore behind. Synthetic fabrics are combined with T-shirts bearing confrontational slogans. Lace and fake fur are used freely. And yet traditional wax fabric has been the oddball star in his recent collections. His boutiques have highly graphic interiors and point to his initial training in architecture.

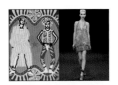

Vivienne Westwood, *Witches* collection, autumn-winter 1983. Since 1981, the British designer finds inspiration in ancestral techniques and ethnic features. © Philippe Waty.
Xuly Bët, spring-summer 2005. Almost androgynous, Xuly Bët's feminine silhouettes here bear boy cuts as well as theatrical makeup by Alice Guendri. The designer has always twisted codes of beauty. In his spring-summer 1999 collection, he painted ephemeral scarifications on his models. A feat, considering the significance and importance that "skin writing" has in traditional Africa. © Olivier Kleisse.

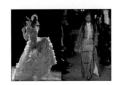

Chouchou Lazare (Gabon), *A lesson of love,* FIMA 2003 in Niger. In a Baroque way, the Gabonese style seems to travel through time while retaining the contemporary feel of a modern woman, divine but strong. © Karim Ramzi.
Alphadi, runway show at the Galliera Museum, July 2004. The usually "classic" Alphadi now plays more and more with materials (raffia, plant fibers, bark, etc.). The result is magnificent. They're enhanced by the regal work of his friend, the great silversmith Mickaël Kra. © Karim Ramzi.

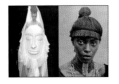

Jean-Paul Gaultier, haute couture spring-summer 2005. Hands down, the star of this sumptuous collection inspired by Africa was this bridal gown made of white tulle. The tulle veil includes a white African mask that covers a large part of the body. © Jean-Paul Gaultier/photo by Marcio Madeira.
Christian Dior, Haute couture spring-summer 1996. Portrait of Kiara Kabukuru (the agency City) by Peter Lindbergh, for Italian *Vogue.* Massai bead jewelry. © Peter Lindberg.

This book accompagnies the young African designers contest
organized by the AFAA (French Association of Artistic Action)
within the framework of the 2005 issue of FIMA
(International Festival of African Fashion), in Niamey, Niger.

The author would like to extend her thanks to Olivier Poivre d'Arvor, director of the
AFAA, Alain Monteil, director of *Afrique en créations* (AFAA), and Tilla Rudel,
commissioner of "L'Afrique est à la mode," who initiated this project, to Martine
Assouline, who gave it its shape with the talent and sensibility that is hers alone, to
Hélène Maza of the AFAA for her precious help, to Stéphanie Guarneri for her image
research, and Valérie Tougard for the text layout.
But this book would not have been possible without the African designers who
graciously made themselves and their work available. They include Alphadi, Juliette
Ombang, Oumou Sy, Xuly Bët, and many others. This book is, above all, for them.

The editor would like to thank Dior press office, Aurore Dury for Xuly Bët, Patrice
Félix Tchicaya, Filomeno agency, Samuel Fosso, Jean-Paul Gaultier press office,
Christophe Lepetit, Michel Mavros, Karim Ramzi, Aminata Sakho for Alphadi, Malick
Sidibé and Helen Tran.

©2006 Assouline Publishing
601 West 26th Street, 18th floor
New York, NY 10001, USA
Tel.: 212 989-6810 Fax: 212 647-0005
www.assouline.com

Color separation: Gravor (Switzerland)
Printed by Grafiche Milani (Italy)

ISBN: 2 84323 800 5

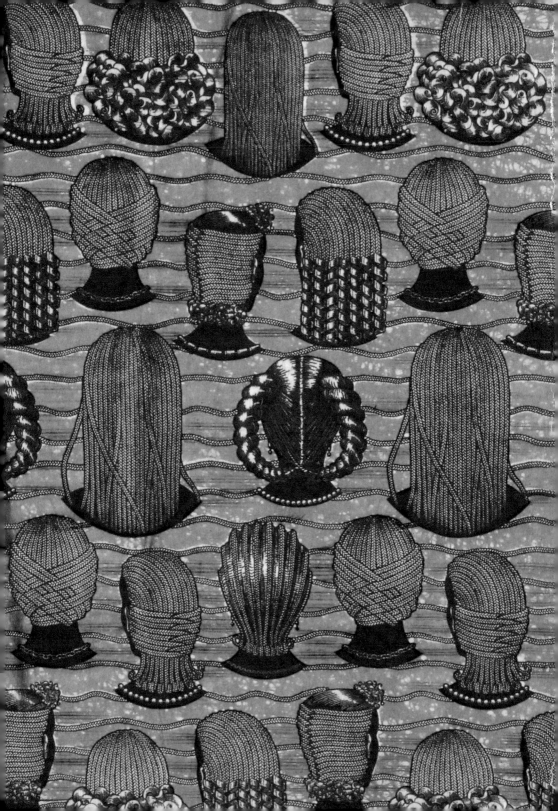